Making Slide Duplicates, Titles & Filmstrips

Making Slide Duplicates, Titles & Filmstrips

BY NORMAN ROTHSCHILD

Third Edition

AMPHOTO
American Photographic Book Publishing Co., Inc.
Garden City, New York

NOTE: All materials and suppliers' addresses in this book are current to the time of writing. Due to constant changes in the industry, however, readers are advised to check before writing manufacturers or attempting to purchase supplies.

Contents

Introduction

The prospective maker of slide duplicates need never fear a lack of suitable equipment. If he is an old hand at photography, each device will fall naturally into its proper niche for him. But to many, the mass of hardware available for sale is naught but an impenetrable maze. Yet things are not as bad as they seem, provided you remember a few basic principles.

The first of these is that in most slide copying we are making a photograph of a transilluminated color transparency. Exceptions to this are when slides are duplicated by contact printing (Chapter 3) and when enlargers and projectors are used (Chapter 6). Unless the original color transparency is very large in size, it is generally necessary to equip your camera for closeup photography. Certain cameras, such as press and view cameras (Chapter 2) and the Rollei SL66 as well as the new Mamiya 6" × 7", have built-in bellows extensions suitable for closeup shooting (Chapter 1). Two twin-lens reflexes, the Mamiyaflex and the Koni-Omegaflex, also offer closeup extensions (Chapter 2). Closeup facilities for other cameras may be supplied either by supplementary closeup attachments or by means of extension tubes or bellows. Ideally, the SLR is the most convenient camera with which to make slide copies in the 35mm or 2¼ size. There are some SLRs such as the Arca Swiss and Plaubel that make larger images, up to 4" × 5", but it is generally more convenient to use a view camera in this and larger sizes,

or to employ an enlarger. Generally speaking, SLRs fall into four categories. These include (1) those having a focal-plane shutter; (2) those with a behind-the-lens leaf shutter; (3) those in which the interchangeable lenses all have their own leaf shutters; and finally (4) those that do not have interchangeable lenses. The first type, covered in Chapter 1, can utilize either closeup supplementary lenses or extension tubes and bellows. The second type generally can employ only closeup lenses, although a few models do take short extensions or utilize some other system for close shooting. Type 3 generally uses special extension tubes, or closeup lenses, whilst type 4 permits the use of closeup lenses only. The SLR list in this Introduction lists which current cameras are useable with what sort of closeup equipment.

In all duping situations, it is also important to have a light source that is evenly distributed. This is generally accomplished by placing a diffusing medium, such as an opal glass, into the system. On duplicating devices that attach to a camera or bellows, this is generally an integral part. In contact printing, even light is often supplied by an enlarger, focused to throw a rectangle of light equal in size to the printing frame. At other times reasonable evenness is obtained by placing a light source far enough from the frame. There are of course professional contact printing machines designed to provide evenly distributed light. The Heitz 35mm Colorcontact Printer (Chapter 3) utilizes a built-in opal diffusion plate. Diffusion systems in enlargers (Chapter 6) differ according to the machine in use.

In addition to even distribution, the light used should have the correct color balance for the film used in slide copying. This problem is covered in Chapter 10.

Still another important requirement for a slide copying set-up is a slide holder, or stage, capable of remaining in a fixed position, so you do not have to put it back into place each time you insert a new slide. There should also be some provision for moving the slide off-center should you decide to copy a section in a corner.

Finally, some provision should be made for placement of filters. The best place for filters is between the light and the original matter to be copied. Where this is not possible, filters designed for good optical performance on the lens should be employed. This includes those made of or mounted in optical glass and gelatin filters. Acetate filters used in color printing, stage gelatins, or stage acetates should not be used in front of an image forming lens, unless some loss of image sharpness can be tolerated.

The problems of making some sort of convenient setup are discussed in Chapter 7. The purpose of this discussion is to help you create a permanent or repeatable relationship between light source and the original. The need for this will become apparent as you try to establish correct and repeatable exposure.

The making of slide titles and filmstrips presents its own special problems. These are covered briefly in Chapters 11 and 12.

These then are the basics of slide duplicating. The information in the various chapters will help you select, set up, and use properly the paraphernalia and films available for this sort of work.

So much for the mechanical end of slide making. The creative end must not, however, be neglected. Just as Oscar Wilde said that art is not the copying of nature, so be it that the mere copying of a slide is not art. To help you get an idea of how far and wide your creative abilities can carry you, see the special chapter on creative techniques at the end of the book.

SLRS FOR SLIDE DUPLICATING

35mm SLRs. FOCAL-PLANE SHUTTER. Permits use of extension tubes or bellows, as well as closeup supplementary lenses. MODELS. Alpa; Argus/Cosina; Beseler Topcon D; Canon SLR; Contarex; Exa; Exakta; Fujica ST701; Hanimex Praktica; Honeywell Pentax; Icarex; Konica Auto Reflex; Mamiya/Sekor;

Miranda; Leicaflex; Minolta SLR; Nikon; Nikkormat; Olympus Pen F; Olympus LC; Petri SLR; Praktina; Prinzflex; Regula 2000; Ricoh SLR; Rollei SL35; Yashica; Zenit.

LEAF SHUTTER. Except for the Retina Reflexes S, III, and IV, which accept a short, 6mm extension, and the Topcon Auto 100 and Unirex and the Contaflex, which use special interchangeable macro optics, all utilize closeup supplementary lenses only. MODELS. Bell & Howell, Auto 35 Reflex; Beseler Topcon Auto 100 and Unirex; Contaflex; Kowa SET and SETR.

2¼ Reflexes. LEAF SHUTTER. Takes special automatic diaphragm extension tubes or bellows. They can also utilize closeup supplementary lenses. MODELS. Hasselblad 500C and EL; Mamiya RB67; and Kowa Six.

FOCAL-PLANE. Also takes extension tubes or supplementary lenses. MODELS. Rollei SL66; Graflex Norita 6 × 6; Bronica; Pentacon Six; and Honeywell Pentax 6 × 7.

126 Reflexes. All of the following cameras, with the exception of the Kodak Instamatic Reflex, which accepts a short, 6mm extension tube, utilize only closeup supplementary lenses. MODELS. Contaflex 126; Instamatic Reflex; Keystone 200; Ricoh 126-C; Rolleiflex SL26.

Larger SLRs. The Makiflex is a focal-plane shutter SLR, while the Arca Swiss Reflex and the Gowlandflex SLR use leaf shutters.

1

Single-Lens Reflexes and Reflex Housings

With a minimum of gadgets, you can use a single-lens reflex to cover subjects as diverse as a distant mountain, a nearby portrait, the original material for a filmstrip, a slide title, and extremely close subject matter, such as a flower, insect, or color slide you wish to duplicate.

Since you view the subject through the same lens that makes the picture, framing and composition are always accurately indicated. There is no parallax error. This is true when you use wide-angle and telephoto as well as normal lenses; when you place extra extensions between lens and camera; and when using accessory closeup lenses. In some reflex cameras, and with reflex housings, you can also check depth of field visually on the groundglass.

Single-lens reflexes may be conveniently divided into three groups:

I. Focal-plane shutter reflexes, by far the largest group.

II. Leaf-type shutter reflexes, with the shutter either directly behind the lens or between the lens elements.

III. Reflexes with interchangeable lenses, each having its own leaf-type shutter.

11

GROUP I. FOCAL-PLANE SHUTTER REFLEXES

In this group you can choose among cameras making standard 24 × 36mm (1″ × 1½″) pictures on 35mm, those making 2¼″ pictures on 120 rollfilm, and large professional reflexes making 4″ × 5″ and 5″ × 7″ images. There are a number of 35mm SLRs that make filmstrip size 18 × 24mm (¾″ × 1″) pictures. These include the Olympus Pen F, the Konica Auto Reflex, which makes either full or single frames, and a special-order model of the Alpa SLR.

By far the most popular are the full frame (1″ × 1½″) 35mm SLRs. Slides made by these are considered standard for amateur use in camera club and exhibition work. Transparencies made with 35mm cameras are generally returned from the processor in 2″ × 2″ cardboard mounts, ready for use in a 35mm slide projector. On the professional side, 35mm slides are widely used for slide lectures, business presentations, salesmen's demonstrations, and in education.

The full frame 35mm reflex can also be used to make "double-frame" filmstrips. Particularly appealing is the low cost of 35mm film material. This leaves the amateur more room for creative experimentation, and is, of course, welcomed by the professional destined to consume lots of raw material. The greatest economy is obtained by buying color film in bulk rolls of 100 feet or more, and reloading empty used cartridges or camera maker's film cassettes. Many types of film, some specially made for duplicating purposes, are available in the 35mm size. (See Chapter 10, "Light, Film, Exposure, and Processing.")

Next in line of popularity are single-lens reflexes making pictures on 120 rollfilm. Image sizes generally are 2¼″ × 2¼″, but there are cameras making 1⅝″ × 2¼″, Super Slide 1⅝″ square, and even full 2¼″ × 3¼″. All the sizes named, except 2¼″ × 3¼″, may be mounted in standard 2¾″ × 2¾″ slide mounts for projection. The larger sizes must be shown in a standard 3½″ × 4″ lantern slide machine, unless trimmed down. Generally speaking, these larger slides are not as much

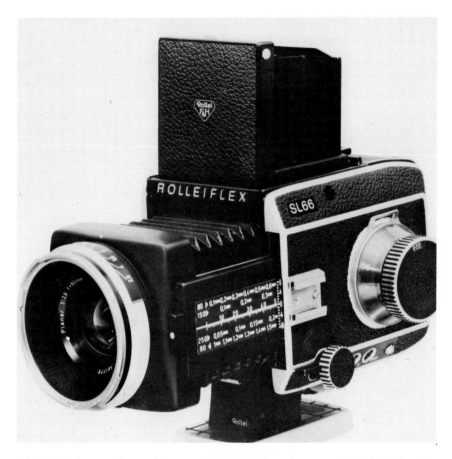

Rollei SL 66 has interchangeable magazines, focal-plane shutter, and built-in bellows for closeups.

in demand for projection and lecture purposes as their 35mm brothers. These larger slides, however, are valuable as originals, being easier to retouch or color correct through masking than 35mm slides. Users of overhead projectors for lecture purposes will also find a certain amount of use for $2\frac{1}{4}'' \times 2\frac{3}{4}''$ and larger slides.

Among the 120 focal-plane reflexes are the Rollei SL66, Graflex Norita 6 × 6, two Bronica models, the Praktisix II (Pentacon Six), and the Honeywell Pentax 6 × 7. The Hassel-

blad 500C and EL, the Kowa Six, and the Mamiya RB67, also 120 reflexes, have separate shutters for each lens (Group III).

The Bronica S features interchangeability of rollfilm magazines. This permits the photographer to change from one film type to another in the middle of a roll. The less expensive model C does not have interchangeable magazines. A rapid return mirror is another feature of both cameras. A wide variety of accessories, such as wide-angle and telephoto lenses, eye-level prism, and extensions, are supplied for the Bronicas. Lenses other than Bronica make can also be easily adapted. The Bronicas make 12 or 24 pictures 2¼″ × 2¼″ on 120 or 220 film, respectively. For the S, there is a magazine making 16 exposures 1¾″ × 2¼″ on 120, or 32 exposures on 220 film.

A recent entry into the 2¼″ × 2¼″ single-lens reflex field is the Rollei SL66. Built-in bellows extension and the ability to reverse the lens permit a great variety of magnifications without extra accessories. The Rollei SL66 uses interchangeable magazines for 120 or 220 film; has a mirror that can be raised for vibration-free exposure; and provides for multiple exposure, an asset in creative duping work. A full line of Zeiss lenses from 50 to 500mm is available. The focal-plane shutter has speeds from 1 to 1/1000 sec. An 80mm and a 150mm lens, each Compur shutter mounted, are available for electronic flash synch to 1/500 sec. Also new are a 70mm magazine and one that makes 1¾″ × 2¼″ transparencies on 120 or 220 film.

The Praktisix II and Pentacon Six make twelve 2¼″ × 2¼″ pictures on 120, or 24 on 220, rollfilm. They are focal-plane shutter reflexes, with full lens interchangeability. For slide copying there are Praktisix bellows extensions and extension tubes. An intermediate ring that maintains the diaphragm automation when automatic lenses are used on extensions is available.

New entries into the 2¼ field include the Kowa Six and the Mamiya RB67, which are leaf shutter reflexes, and the Graflex Norita 6 × 6 and Honeywell Pentax 6 × 7, which have focal-

plane shutters. The RB67 and the Pentax 6 × 7 make 2¼″ × 2¾″ images, ten on 120 film and twenty on 220 film. This "ideal-format" image size enlarges directly to 8″ × 10″ without cropping.

Closeups with single-lens reflexes can be accomplished using either closeup lenses, extension tubes, or extension bellows. There are also special macro lenses that have their own built-in extension, letting you make closeups to 1:1 or larger without extra accessories. Closeup lenses offer simplicity of operation. They are slipped onto the camera lens in the same manner as a filter. No increase in exposure is required. Compared with ex-

Above, the Spiratone Variable Magnification (VM) Duplicator fits directly on the lens. It may be used with tube or bellows extensions or may be mounted directly on a macro lens.

Extension tubes allow a series of repeatable relatively fixed magnifications. (Accura photo.)

tension tubes and bellows, the range of closeup lenses is rather limited. They will be found useful chiefly in shooting original material for later duplication, and in making titles and film-strips from large art work.

The range of image sizes obtainable by the use of extensions can be gleaned by consulting Table 2. From this it can be seen that the longer the extension used with a given focal length lens, the larger the image magnification. The range is great enough for you to make 1:1 duplicates if you like, or to crop out sections of slides for better composition.

Special slide copying devices that fit on the ends of the extension bellows are offered by several manufacturers. These are discussed later on in this chapter.

LARGE SINGLE-LENS REFLEXES

Reflexes in 3¼″ × 4¼″, 4″ × 5″, and 5″ × 7″ are seldom used by amateurs for slide duplicating. They are used occasionally by professionals to make large transparencies from small

slides. A more frequent use for large reflexes is in the production of originals from which reduced duplicates are to be made. The large transparencies from these cameras may also find some use in overhead projectors. Where color retouching, masking, combination printing, and stripping operations are to be undertaken, the large area of these transparencies will prove to be a distinct advantage.

Recently several larger-format SLRs have reached the U.S. market. These include the Makiflex, Arca Swiss, and the older Gowlandflex.

The Gowlandflex makes pictures up to 4″ × 5″ in size. It is equipped with a Graflok-type back, which accepts 4″ × 5″ film holders, a Polaroid sheet film holder, and rollholders for 120, 220, 70mm, and even 90mm film. The shutter has only one speed, 1/50 sec., and is synched for electronic flash. Viewing is from eye-level via a mirror arrangement. Data on this camera may be obtained from Peter Gowland, Santa Monica, Calif.

The Makiflex, imported by Olden Camera, New York, N.Y., makes pictures from 35mm up to 3½ inches in size. Picture sizes 1⅝″ × 2¼″, 2¼″ × 2¼″, 2¼″ × 3¼″, and 35mm are made via rollholders. The Makiflex will also take 2½″ × 3½″ sheet film, filmpack, and plates. The full 3½″ × 3½″ image size is realized by the use of standard 4″ × 5″ film holders. It is also possible to make a 3½″ × 3½″ image on 4″ × 5″ Polaroid film. Accessory equipment obtainable for the Makiflex adds view camera swings and tilts. Some Makiflex lenses have automatic diaphragms.

The Arca Swiss Reflex, imported by Bogen Photo Corp., Englewood, N. J. 07631, is capable of making images in a great variety of formats from 2¼″ × 3¼″ to 4″ × 5″, including Polaroid film. The basic camera is part of a "building block" system, and a large number of configurations are possible through choice of accessories such as bellows, swings, and special hoods.

Other large reflexes are chiefly on the second-hand market. The cameras most frequently encountered are those of Graflex

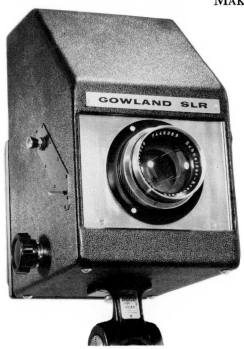

Gowlandflex, above, and Arca Swiss Reflex, below, permit use of several film formats up to 4" x 5".

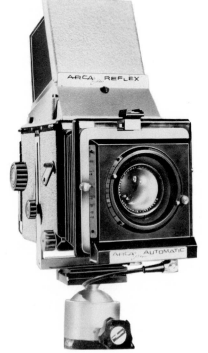

TABLE 1

CLOSE-UP DATA FOR 50MM LENSES					CLOSE-UP DATA FOR 58MM LENSES				
Length of ext. in mm.	Dist. fm sub. to lens in mm.	Tot. dist. fm film to sub. in mm.	Scale of subject image to life size	Req. exp. inc.	Length of ext. in mm.	Dist. fm sub. to lens in mm.	Tot. dist. fm film to sub. in mm.	Scale of subject image to life size	Req. exp. inc.
0	infinity	infinity	variable	1.00	0	infinity	infinity	variable	1.00
5	550	605	0.1	1.21	5	731	794	0.09	1.18
10	300	360	0.2	1.44	10	394	462	0.17	1.37
15	217	282	0.3	1.69	15	282	355	0.26	1.59
20	175	245	0.4	1.96	20	226	304	0.35	1.81
25	150	225	0.5	2.25	25	192	275	0.43	2.05
30	133	213	0.6	2.56	30	170	258	0.52	2.30
35	121	206	0.7	2.89	35	154	247	0.60	2.60
40	113	203	0.8	3.24	40	142	240	0.69	2.85
45	106	201	0.9	3.61	45	133	236	0.78	3.17
50	100	200	1.0	4.00	50	125	233	0.86	3.46
70	86	206	1.4	5.76	70	106	234	1.21	4.87
100	75	225	2.0	9.00	100	92	250	1.72	7.42
120	71	241	2.4	11.60	120	86	264	2.07	9.42
150	67	267	3.0	16.00	150	80	288	2.58	12.90
CLOSE-UP DATA FOR 105MM LENSES					CLOSE-UP DATA FOR 135MM LENSES				
0	infinity	infinity	variable	1.00	0	infinity	infinity	variable	1.00
5	2310	2420	0.05	1.10	5	3780	3920	0.04	1.07
10	1208	1323	0.10	1.21	10	1958	2103	0.07	1.15
15	840	960	0 14	1.30	15	1350	1500	0.11	1.23
20	656	781	0.19	1.42	20	1046	1201	0.15	1.32
25	546	676	0.22	1.49	25	864	1024	0.19	1.40
30	473	608	0.29	1.66	30	743	908	0.22	1.49
35	420	560	0.33	1.77	35	656	826	0.26	1.59
40	381	526	0.38	1.90	40	591	766	0.30	1.68
45	350	500	0.43	2.05	45	540	720	0.33	1.78
50	326	481	0.48	2.19	50	500	685	0.37	1.88
70	263	438	0.67	2.79	70	395	600	0.52	2.30
100	215	420	0.95	3.80	100	317	552	0.74	3.03
120	197	422	1.14	4.58	120	287	542	0.89	3.57
150	178	433	1.43	5.91	150	256	541	1.12	4.49

Courtesy Tiffen Optical Co.

make. The last model produced by Graflex was the Super D in 3¼″ × 4¼″ and 4″ × 5″ sizes. This had an automatic diaphragm (the first such device offered for a single-lens reflex), focal-plane and open flash synchronization, and a revolving back for vertical and horizontal shots.

GROUP II. LEAF SHUTTER REFLEXES

In this group are cameras in which the shutter is located between the lens elements and the front components are interchangeable (Contaflex, Fujicarex), or fully interchangeable

TABLE 2

TIFFEN CLOSE-UP LENS (diopters)	Footage Setting on Camera	Inches from Subject to Close-Up Lens	AREA SEEN BY LENS (inches)			
			50mm Lens 24 x 36mm Negative	50mm Lens 28 x 40mm Negative	75mm Lens 2¼ x 2¼-in. Negative	100mm Lens 2¼ x 3¼-in. Negative
+1	Inf.	38¾	18⅝ x 28	21⅞ x 31¼	30 x 30	22⅛ x 32
	50	37	17¾ x 26⅝	20½ x 29¼	28 x 28	21 x 30¼
	25	34¾	16⅝ x 25	19¼ x 27½	26⅛ x 26⅛	19⅝ x 28⅜
	"FIXED"	33¾	16 x 24	18¾ x 26¾	25½ x 25½	19 x 27½
	15	32⅜	15⅜ x 23	17⅞ x 25½	24¼ x 24¼	18¾ x 27⅛
	10	29⅝	14 x 21	16⅛ x 23⅛	22 x 22	16⅜ x 23⅝
	8	27⅞	13⅛ x 19¾	15⅛ x 21⅝	20½ x 20½	15¼ x 22⅛
	6	25½	11⅞ x 17⅞	13¾ x 19⅝	18⅝ x 18⅝	13¾ x 19⅞
	5	23¾	11 x 16⅝	12¾ x 18¼	17⅛ x 17⅛	12¾ x 18⅜
	4	21⅝	10 x 15	11½ x 16½	15⅜ x 15⅜	11⅜ x 16⅜
	3½	20⅜	9¼ x 14	10¾ x 15⅜	14⅜ x 14⅜	10½ x 15¼
+2	Inf.	19½	9⅜ x 14	10⅞ x 15½	14¾ x 14¾	11⅛ x 16⅛
	50	19⅛	9⅛ x 13⅝	10½ x 15⅛	14⅜ x 14⅜	10¾ x 15⅝
	25	18½	8⅞ x 13¼	10¼ x 14⅝	13⅞ x 13⅞	10⅝ x 15
	"FIXED"	18	8⅝ x 12⅞	10 x 14¼	13½ x 13½	10⅛ x 14⅝
	15	17¾	8½ x 12¾	9⅞ x .14	13⅛ x 13⅛	9⅞ x 14⅜
	10	16⅞	8 x 12	9¼ x 13¼	12½ x 12½	9⅜ x 14
	8	16⅜	7¾ x 11½	8⅞ x 12¾	12 x 12	8⅞ x 12⅞
	6	15½	7¼ x 10⅞	8⅜ x 12	11¼ x 11¼	8⅜ x 12
	5	14⅞	6⅞ x 10⅜	8 x 11½	10¾ x 10¾	7⅞ x 11⅜
	4	14	6½ x 9⅝	7½ x 10¾	10 x 10	7¼ x 10½
	3½	13⅜	6⅛ x 9¼	7⅛ x 10⅞	8⅞ x 8⅞	6⅞ x 10
+3	Inf.	13	6¼ x 9⅜	7¼ x 10⅜	9⅞ x 9⅞	7½ x 10¾
	50	12⅞	6⅛ x 9¼	7⅛ x 10¼	9⅝ x 9⅝	7¼ x 10½
	25	12½	5⅞ x 8⅞	6⅞ x 9⅞	9⅜ x 9⅜	7⅛ x 10¼
	"FIXED"	12⅜	5⅞ x 8⅞	6⅞ x 9¾	9¼ x 9¼	7 x 10
	15	12¼	5¾ x 8¾	6¾ x 9⅝	9⅛ x 9⅛	6⅞ x 9⅞
	10	11⅞	5⅝ x 8⅜	6½ x 9¼	8¾ x 8¾	6½ x 9½
	8	11½	5⅜ x 8⅛	6¼ x 8⅞	8⅜ x 8⅜	6⅜ x 9⅛
	6	11⅛	5⅛ x 7⅞	6 x 8⅝	8 x 8	6 x 8⅝
	5	10¾	4⅞ x 7½	5¾ x 8¼	7¾ x 7¾	5¾ x 8¼
	4	10⅜	4¾ x 7⅛	5½ x 7⅞	7⅜ x 7⅜	5⅜ x 7¾
	3½	10	4½ x 6⅞	5¼ x 7½	7 x 7	5¼ x 7½
+4 (3 + 1)	Inf.	9⅞	4⅝ x 7	5½ x 7¾	7⅜ x 7⅜	5⅝ x 8⅛
	"FIXED"	9½	4½ x 6⅝	5⅛ x 7½	7 x 7	5⅜ x 7¾
	3½	8	3⅝ x 5⅜	4⅛ x 6	5½ x 5½	4⅛ x 6
+5 (3 + 2)	Inf.	7⅞	3¾ x 5⅝	4¼ x 6¼	5⅞ x 5⅞	4½ x 6½
	"FIXED"	7⅝	3½ x 5⅜	4⅛ x 6	5⅝ x 5⅝	4¼ x 6⅛
	3½	6½	3 x 4⅜	3½ x 4⅞	4½ x 4½	3⅜ x 4¾
+6 (3 + 3)	Inf.	6½	3 x 4⅝	3⅝ x 5⅛	4⅞ x 4⅞	3¾ x 5⅜
	"FIXED"	6⅜	3 x 4⅜	3⅜ x 4⅞	4¾ x 4¾	3⅝ x 5¼
	3½	5⅝	2½ x 3¾	3 x 4¼	3⅞ x 3⅞	2⅞ x 4¼
+8	Inf.	5⅛	2¼ x 3⅜			
	4	4⅝	2 x 3			
+10	Inf.	4¼	1⅞ x 2¾			
	4	4	1⅝ x 2½			

Courtesy Tiffen **Optical Co.**

models in which the shutter is directly behind the lens. The latter include Retina Reflex S, III, IV; Kowa SET R2; Topcon Auto 100 and Unirex; Voigtlander Bessamatic and Ultramatic; Edixa Electronica. Non-interchangeable models include Kowa SET; Mamiya 528TL; and Cavalier Reflex.

Unlike their focal-plane shutter relatives, leaf shutter reflexes cannot utilize extension tubes for closeup work. Instead,

closeup lenses must be used. Image magnifications possible with these preclude making 1:1 copies from slides.

The slide copying situation with these cameras, however, is not hopeless. By means of accessory slide copiers, such as the Lectro Duplicator, same-size, or 1:1, duplicates can be made. The use of these is covered in Chapter 2, under the heading "Universal Devices." Cropped slides may also be made by using Lectro Duplicators on telephoto lenses. This is also covered in Chapter 2. For Contaflex III, IV, Super, and Rapid cameras, the front element may be interchanged for a Pro-Tessar M, which permits making 1:1 copies. Special copying kits for use with Retina IIIS, Retina Reflex S, III, and IV cameras, and Voigtlander Bessamatic and Ultramatic cameras are discussed in Chapter 4. Kits for the latter two cameras have been discontinued.

GROUP III. REFLEXES WITH SHUTTER IN EACH LENS

The old series of Hasselblads, the 1600F and 1000F, were the first 120 reflexes to feature interchangeable magazine backs. With the Hasselblad 500C and its motorized version, the 500EL, three different types of magazine are supplied for 120 film. Model 12 makes 12 pictures $2\frac{1}{4}'' \times 2\frac{1}{4}''$; model 16 makes 16 pictures $1\frac{5}{8}'' \times 2\frac{1}{4}''$; and model 16S makes 16 pictures $1\frac{5}{8}'' \times 1\frac{5}{8}''$, or twice as many shots on 220 film. A 70mm magazine allows up to 72 shots per load. Interchangeable lenses from 40 to 500mm are available. All have automatic diaphragms and depth-of-field preview. Unlike the 35mm leaf shutter reflexes discussed in Group II, the Hasselblad 500C can utilize extension tubes and bellows for closeup work. Hasselblad extensions have a shaft mechanism that transfers the automatic operation from camera to lens.

A number of lenses that incorporate a leaf shutter are available for the Rollei SL66. When these are used instead of the built-in focal-plane shutter, more versatile flash and electronic flash synch are possible with this camera. Other cameras that use leaf-type shutters for individual lenses are the Kowa Six and the Mamiya RB67.

The "ideal-format" RB67 has a built-in bellows, permitting extreme closeups without accessories. For still closer work, extension tubes are supplied. It also has a revolving back, which permits vertical or horizontal pictures without your turning the camera on its side. All may be furnished with interchangeable lenses and accessory extension tubes or bellows.

HINTS ON THE USE OF SINGLE-LENS REFLEXES

As we have seen previously, closeups with cameras of this type can be made with either closeup lenses, extensions, or special macro lenses.

While closeup lenses have the advantage of simplicity of operation, requiring no recalculation of exposure, the range is more limited than when extensions are used. Another factor, too, must be taken into consideration. This is the loss of sharpness incurred when any type of simple supplementary lens is added to an optical system. With +1, +2, and +3 lenses and medium to small lens openings, definition will generally be adequate for amateur duplicating, titling, and filmstrip making. The definition secured with lenses stronger than +5 will generally be found acceptable only if the smallest stops are used. To avoid out-of-focus images when strong supplementaries are used, focus using the smallest diaphragm opening that passes enough light for you to see with. If the light is too dim to permit focusing at stops equal to or smaller than three stops above the one you are going to use, you may run into trouble from blur caused by "focus shift." This latter is the result of any additional spherical aberration introduced by the supplementary lens.

For a greater range and more critical definition than is possible with closeup lenses, extension tubes or bellows should be employed.

Cameras in Group II must use supplementary lenses for closeup work. They cannot use extension tubes or bellows.

TUBES OR BELLOWS?

Extension tubes offer greater rigidity than most bellows extensions. They are preferred whenever rough handling is a

possibility or where bellows could be damaged by insects, fungus, or damp. Extension tubes limit you to a series of relatively fixed magnifications, depending on tube length or tube combinations used. These magnifications, however, are easy to repeat exactly.

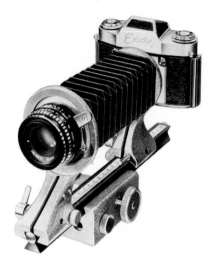

Bellows extensions give continuously variable magnifications. (Courtesy Ponder & Best, Inc.)

Extension tubes for series of fixed magnifications. (Courtesy Karl Heitz, Inc.)

Bellows extensions are continuously variable, giving you a greater flexibility than tubes. Many of these, in deluxe version, have provision for the camera to be turned from vertical or horizontal position without having to move the bellows themselves. Other deluxe versions feature an extra rack-and-pinion track, which permits moving the entire camera-bellows assembly nearer and farther from the subject without disturbing tripod or coping stand setup. Others let you use view camera lenses, which include lenses specially suited for copying, via interchangeable lensboards.

BELLOWS SLIDE COPYING UNITS

If you now own or contemplate owning an extension bellows, you'll seriously consider buying one of the accessory units that convert it into a slide copying device. Such units include the Balcop for the Novoflex bellows, and similar units by Nikon, Spiratone VM, Topcon, Minolta, Pentax, Accura, and Hasselblad.

Essentially, each unit consists of a short supplementary bellows or tube, as in the Spiratone VM Duplicator, which is attached before the camera lens. At the front end of this is a slide holder and a ground or opal glass to diffuse the light. The units that fit 35mm camera bellows accept 2″ × 2″ slides, the copying area being a maximum of 1″ × 1½″. Units for the 2¼″ SLRs accept 2¾″ square slide mounts. Magnification can be varied from 1:1 or larger, the exact maximum depending on the individual unit.

The advantage of a bellows copying device is that the entire camera–bellows–slide-copier assembly becomes one integrated slide duplicating unit. This unit can then be mounted on a copying stand, tripod, or other support in relation to a light source. This latter may include daylight, electronic flash, or tungsten lamps.

EXPOSURE INCREASE WITH EXTENSIONS

When using extension tubes or bellows, extra exposure must be given. With cameras not having through-the-lens metering systems, this must be recalculated. The amount of extra exposure is generally engraved on the focusing tracks of extension bellows. Where this is not the case, or when you are using extension tubes, consult the figures in Table 2 under the heading "Required Exposure Increase." Where odd extensions not shown in the table are to be used, the increased exposure factor may be found by using the following formula:

$$\frac{\text{Total extension}^2}{\text{Lens focal length}^2} = \text{Exposure factor}$$

Thus, using a 50mm lens plus a 150mm of extension tubes or bellows, the total extension will be 200mm. Squaring this, we get 40,000. Squaring 50, we get 2,500. Dividing 40,000 by 2,500, we get 16, or an exposure factor of 16^\times. The extra exposure is calculated automatically in cameras having through-the-lens exposure metering systems.

MACRO LENSES

Lenses in this group permit continuous focusing from infinity to extreme closeups without recourse to accessory extensions or closeup lenses. The extra needed extension is built into the lens mount. Image magnifications up to 2:1 are obtainable. The first lens of this type to reach the American market was the 40mm $f/3.5$ Makro-Kilar with manual diaphragm. Current Makro-Kilars include a 40mm and 90mm $f/2.8$, both with preset diaphragms. Since the introduction of the Makro-Kilars, the list of these lenses has grown enormously. At this writing included are 35mm $f/3.5$ Novoflex (0.5:1); Minolta 50mm $f/3.5$ Macro Rokkor (to 1:1); 55mm $f/3.5$ Micro-Nikkor (1:1); 60mm $f/2.8$

Mamiya Macro (1:1); 35mm $f/2.8$ Steinheil Macro Quinaron (2:1); 55mm $f/1.9$ Steinheil Macro Quinon (1.4:1); 100mm $f/2.8$ Steinheil Macro Quinar (1:1.3); 135mm $f/2.8$ Steinheil Macro Tele-Quinar (1:1.8); 50mm $f/2.8$ Schacht Macro Travenar (1:1); 50mm $f/2.8$ Exakta Macro Extenar (1:1); Pentax 50mm $f/4$ Macro Takumar (1:1); Konica 55mm $f/3.5$ Macro Hexanon (1:1).

With the addition of the Spiratone VM Duplicator, these become a self-contained duping unit, requiring only a light source.

With through-the-lens metering cameras, the extra exposure required by the lenses at appreciable extension is no longer a serious problem, since it is calculated automatically. For other cameras, magnification and exposure compensating scales usually found on these lenses make this easy to do.

Where extra magnification, beyond the range each lens is capable of delivering normally, is desired, these lenses may be mounted on a bellows or tube extension, or plus (+) supplementary closeup lenses may be employed.

It should be pointed out that for duping mounted slides a magnification of 1:1 will not fill the picture frame in the camera, since the openings in slide mounts are slightly smaller than the full format. Here the use of fractional diopter (+¼ and +½) closeup lenses as offered by Spiratone, Tiffen, and Ponder & Best will give the *slight* extra magnification needed.

Macro effects may also be obtained by reversing a normal camera lens. Devices that allow this are sold by Spiratone, Schacht, Soligor, Seymours, Samigon, and many others. The magnification obtained is a fixed one. $F/$stops remain unchanged.

Another approach to macro work is to purchase a bellows extension and mount on it special short or barrel mount lenses. The pioneer in this field is Leitz. Today such lenses are supplied by Spiratone, Novoflex, Beseler, Nikon, Minolta, Zeiss, and others. For this sort of work most have manual diaphragms, except the Zeiss 115mm $f/3.5$ Tessar and several of the Novoflex lenses, which have automatic diaphragm provision.

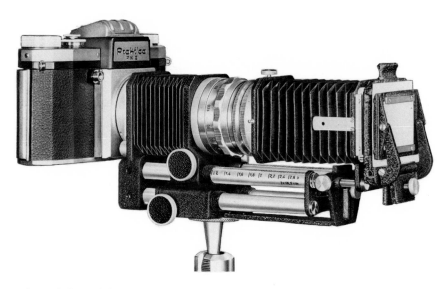

Above, bellows slide copying devices are offered by several makers. This one is a Novo-flex from Burleigh Brooks, Inc.

Below, marco lenses allow extreme closeups, to 1:1 with no need for extra extensions. Upper is Makro-Kilar, lower is Micro-Nikkor.

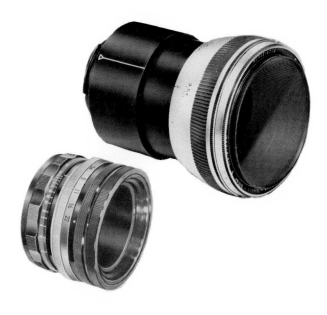

LENS QUALITY

In most instances, the amateur photographer or the professional making an occasional dupe will want to utilize the normal lens that came with his camera. In general, adequate results can be obtained, even with $f/2$ and $f/1.4$ normal lenses that have not been designed for closeups, provided a few precautions are followed. At close ranges used in duplicating, the images from wide open high speed lenses will generally be found too fuzzy to permit critical focus. Focusing will be found easier if the aperture is stopped down to about $f/5.6$. Normal lenses of $f/2.8$ or $f/3.5$ aperture can generally be focused quite well at full opening. For highly critical work, lenses specially suited for closeups and copying should be used. Among these are enlarging lenses. Some of these, such as the 50mm Componars and Componons, Sterling-Howard Amitars, Spiratone Dialites, Leitz Focotars, and Nikon EL-Nikkors, can be supplied with mounting threads and adapters to allow these to be used on various 35mm camera bellows. For extremely critical work, you may wish to use a highly corrected view camera lens such as the Goerz Red Dot Artar, Schneider Claron, Apo-Lanthar, Apo-Tessar, Goerz Dagor, or Apo-Raptar. One of these can be mounted on the lensboard of the Accura Bellowsmaster or be adapted to other bellows by a camera repair shop.

VIEWFINDERS

Most 35mm single-lens reflexes are supplied with built-in eye-level prisms. While this is convenient for most ordinary picture taking, you may find it difficult to view the ground glass when the camera is mounted high on a copying stand. One solution is to clamber onto a chair or ladder. A better solution is to buy a right-angle viewfinder, where this is offered by the maker. Among such finders are those supplied for the Minolta, Leicaflex, Honeywell Pentax, Konica Auto Reflex, and some models of the Retina Reflex.

Where your reflex camera has an interchangeable viewfinder, you'll find replacing the prism with a waist-level finder will provide more convenient viewing and focusing angles.

OTHER FEATURES

Vibration from mirror and shutter movement can cause severe blurring in duping. The use of electronic flash minimizes this; however, many workers prefer other light sources. For them a provision to keep the mirror locked up will prove a boon. This feature may be found in certain Nikon, Nikkormat, Minolta, Miranda, and Contarex models.

The Exakta's long automatic exposures, ranging from 1/8 to 12 seconds, may prove a boon in making dupes from dense slides with continuous light sources. The 250-exposure backs for various reflexes will be of inestimable value for making dupes or titles in quantity. The Nikon F2 also makes long exposures.

Where a single-lens reflex is to be used for trick and double exposures, make sure that the double exposure prevention devices can be bypassed easily.

One final bit of advice. If duplicating, titling, or filmstrip making are to be a major part of your work, check camera and accessory maker's catalogues carefully to make sure that all necessary equipment is available to fit the camera you contemplate using. A check should also be made on the rigidity and durability of items. Inexpensive bellows, tubes, and other paraphernalia are quite all right for amateur use, but may not stand up long under continued professional use.

REFLEX HOUSINGS

Reflex housings convert rangefinder and some non-rangefinder cameras having lens interchangeability into single-lens reflexes. Rangefinder cameras in this group include thread and bayonet Leica models; cameras similar to Leica, such as Nicca,

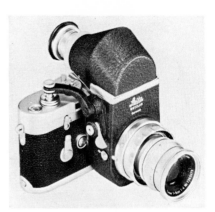

Reflex housings convert RF cameras into single-lens reflexes. Shown is Leitz Visoflex II. Other makers include Komura, Nikon, Canon, and Novoflex.

Tower, and Leotax; Canon; Contax II, IIa, III, IIIa; and Nikon S, S2, S3, SP. In the non-rangefinder group are Leicas 1G and M1, as well as older similar models.

Since a reflex housing adds to the camera thickness, it is, in effect, an extension tube. Because of this, normal and wide-angle lenses cannot be used for infinity shooting. Most earlier reflex housings accepted only 135mm or longer lenses for infinity shooting. Newer models, such as the Komura and the Leitz Visoflex II and III, take lenses as short as 90mm. For the Visoflex II and III there is a special "long-normal" 65mm $f/3.5$ Leitz Elmar lens.

Both extension tubes and bellows can be employed with reflex housings. However, bellows extensions are generally used by most workers.

A special advantage of reflex housings is that mirrors incorporated in these are longer than those installed in most SLRs. In the latter, the mirror must be short enough to clear the rear element of wide-angle lenses. Because of this, part of the image cast by a long-focus lens, or a lens on a long extension, never reaches the mirror of some single-lens reflexes. This results in part of the upper portion of the ground glass blacking out, showing you less than will appear on the film. This problem is not encountered in reflex housings.

Most reflex housings have provision for rotating the camera from vertical to horizontal position. Slide copying attachments similar to those described above for reflex bellows attachments are also available for use with reflex housings. Such devices are offered by Novoflex for use with bellows of their own make, Accura, Pentax, Topcon, Minolta, Nikon, and others.

Special right-angle finder on Contaflex. Such finders, made also by Minolta, Pentax, Konica, Mamiya/Sekor, Nikon, and Kodak for their own cameras, provide convenient copying viewing angle.

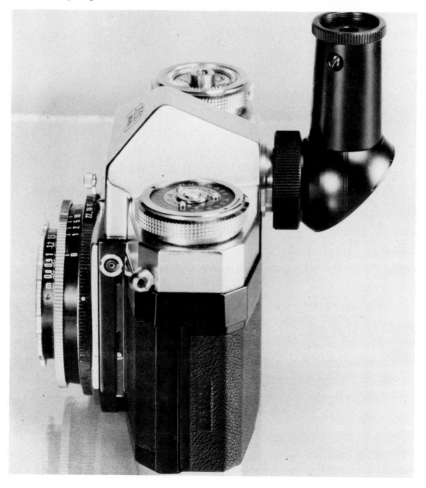

2

Various Cameras

In this chapter we'll explore the interesting possibilities inherent in the use of view, press, and twin-lens reflex cameras for slide duplication.

VIEW AND PRESS CAMERAS

In this era of the miniature camera, the versatility of less glamorous view and press cameras is often overlooked. In addition to being able to perform most jobs assigned to miniature cameras, there are certain duplicating jobs that can only be done properly and with some semblance of ease with a press or view camera.

Focusing in view and press cameras is accomplished via a parallax-free ground glass. Unlike miniature cameras, which require complicated devices or special lenses, view and press cameras accept any appropriate focal length lens by means of simple flat lensboards.

The lateral movements incorporated in the front of press and view cameras will be found a great help in centering desired portions of the image to be copied on the film.

The swings of view and of some press cameras will be found invaluable in removing perspective distortions introduced

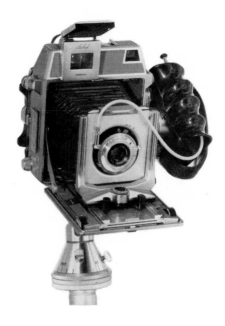

Press and view cameras make large pictures and have corrective swings and tilts. Above is Linhof 23 Press. Below is Calumet View.

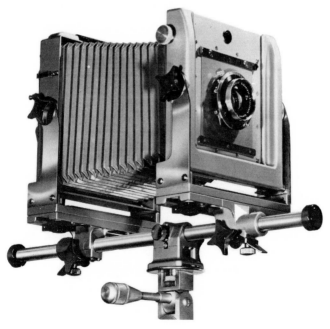

into a color slide by pointing the camera upward or downward. These distortions are particularly noticeable in architectural subjects. Purposeful distortions for some creative effect can also be introduced using swings.

Since view and press cameras make pictures $2\frac{1}{4}'' \times 3\frac{1}{4}''$, $4'' \times 5''$, $5'' \times 7''$, or $8'' \times 10''$ on sheet film, they are often used to make blowups from small slides. Individual sheets of film can be given special processing for special effects.

While the basic material used in view and press cameras is sheet film, many can be adapted to take 120 rollfilm and in some cases 35mm and 70mm films. The use of these films cuts costs and avoids frequent reloading and individual handling of each exposure in processing. Sources of press and view cameras that accept 120 rollholders include Graflex, Inc., Rochester, N. Y. 14603 (Speed, Crown, and Super Graphics and Graphic View); Karl Heitz, Inc., New York, N. Y. (Sinar View); Kling Photo Corp., New York, N. Y. 10010 (Linhof Press and View); Bogen Photo, Englewood, N. J. (Arca View); EPOI, Garden City, N.Y. (Plaubel Peco View); and Burleigh Brooks, Inc., Hackensack, N. J. (Favero View). Many of these cameras are adaptable to 120, 220, and 70mm film via special rollholders.

Mounting a 35mm camera on a view camera makes for an extremely flexible arrangement. Generally speaking, the bellows of a view camera is longer than that of most miniature camera accessory bellows. Thus, greater image magnifications are possible. Since for a given magnification, longer lenses require more extension than shorter ones, extra extension will be found useful where very long lenses are to be used for macro work. The use of such lenses allows greater lens-to-subject distances, making it easier to place lights and make f/stop changes. Most makers of SLRs supply lens flanges so that their lenses can be used on an enlarger. Such flanges may be used on the lensboards of press and view cameras. Hardware for this sort of operation is supplied by Burke & James, Chicago, Ill. 60604, Associated Arts, Paillard, Inc., Linden, N. J., and others.

Associated Arts adapter lets you use your SLR on view and press cameras.

Latest 4" x 5" Super Graphic is versatile instrument for industrial, commercial, illustrative photography. It is relatively light for a 4" x 5" camera. (Graflex, Inc.)

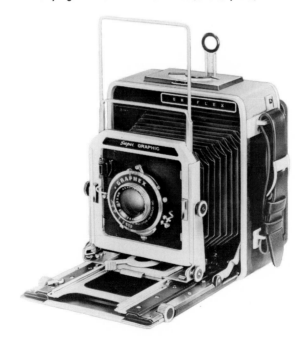

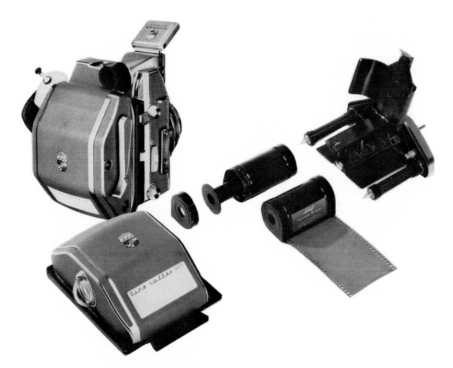

70mm cassettes for Linhof cameras have capacity of 50 exposures, are useful for making large dupes in quantity. Adapters to make a variety of image sizes on 120 or 220 film are offered by Linhof, Graflex, Sinar, and Calumet. Graflex also makes a 70mm adapter.

Adaptations such as 35mm and 70mm backs holding film in lengths up to 100 feet can be made to order by Burke & James, Inc. (See Chapter 8, "Duping Slides in Quantity.")

TWIN-LENS REFLEXES

Two basic problems that beset twin-lens reflexes make their usefulness in slide duplicating rather limited. These are parallax, or difference in viewpoint between taking and viewing lens, and insufficient extension.

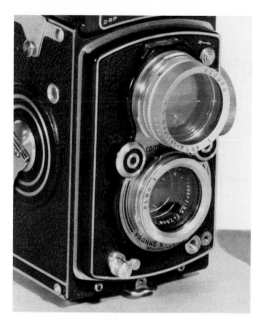

Spiratone and other closeup lens sets permit closeups to 10 inches.

Closeup Lens Sets

The closeup attachments that are normally supplied for twin-lens reflexes consist of a pair of matched plus lenses. Parallax is corrected by adding a prism factor to the upper lens. This shifts the image on the ground glass so that its framing is the same as that of the taking lens. With a +1 closeup set, the field of view, or area seen by the lens, at the closest working distances averages about 13″ × 13″; with a +2 set, this is about 8⅝″ × 8⅝″; and with the strongest available parallax corrected set, a +3, the field of view is about 6¾″ × 6¾″. These figures vary a bit from camera to camera. They are quoted for a 75mm lens. Cameras with 80mm lenses have a slightly smaller field of view. These fields of view are hardly conducive to copying anything but large transparencies.

The obvious answer is to use stronger closeup lenses. How this can be done is explained below.

Mechanical Parallax Correction

Parallax can be completely eliminated by the use of mechanical devices such as the Spiratone Parallax Eliminator for all TLRs (except Mamiyaflex); Minolta Paradjustor for Minolta Autocord (this works for Rolleis and Yashicas, too); and the Mamiya Paramender for Mamiyaflex cameras. These devices raise the taking lens to a position formerly occupied by the finder lens, after focusing and composing have been accomplished. By means of mechanical parallax adjusters, extra strong closeup lenses, to +10, may be used. With the +10 the area seen by a 75mm or 80mm lens, with the camera lens set at about three feet is approximately 2⅜" × 2⅜". With the Mamiyaflex and its bellows extension greater magnifications are possible.

For 1:1 copying Spiratone, Inc., supplies a set consisting of a pair of strong closeup lenses in bayonet mounts for various TLRs and a mechanical Spiratone parallax compensator.

Strong +10 closeup lenses are available from **Spiratone**, Tiffen, and others.

Mechanical parallax compensators should not be used with closeup sets for TLRs that have parallax compensation via a prism factor in the upper supplementary system.

Definition with Closeup Lenses

All closeup or supplementary lenses affect definition adversely—the stronger the lens, the worse the problem. It is

Principle of the mechanical parallax corrector. (Courtesy Spiratone, Inc.)

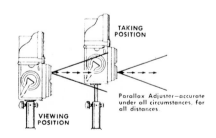

therefore advisable to use the smallest stop possible in order to give the best degree of sharpness in the dupe.

Making Enlarged Dupes from 35mm Slides

By attaching a Lectro Slide Duplicator to your twin-lens reflex you can make enlarged duplicates of 35mm slides. This is covered in Chapter 4, "Duping with Fixed Focus Devices." Picture size of the enlarged dupe is about $1\frac{5}{8}'' \times 2\frac{1}{4}''$.

The Rollei Plate Back

This adapts Rolleiflex and Rolleicord cameras, with the exception of the Rollei "T," Rolleimagic, and 4 × 4cm models, to make single exposures $2\frac{1}{4}'' \times 2\frac{1}{4}''$ on $2\frac{1}{2}'' \times 3\frac{1}{2}''$ sheet film.

By means of a special technique and the use of a +10 close-up lens approximately 1:1 copies can be made.

To do this the ground glass focusing screen slide is used. This looks like a filmholder, but places a groundglass at the rear focal plane of the lower, or taking, lens to provide parallax-free focusing and composing.

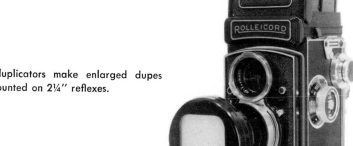

Lectro duplicators make enlarged dupes when mounted on 2¼" reflexes.

To use, set the shutter at "B," using a locking cable release to keep it open for focusing. A +10 closeup lens is placed on the taking lens. The camera lens is set for its closest working distance. The slide of the ground glass focusing device is withdrawn just *far enough* to uncover the ground glass. This prohibits the ground glass from moving forward up against the film gate, thus, in effect, providing extra extension. After focusing and composing, remove the focusing screen slide, and substitute a holder for the exposure. After you withdraw the holder slide, *do not operate* the button on back of the holder, which is ordinarily used to permit the film to pop forward against the film gate. Instead, make the exposure with the film in the rear position. For best definition, small to medium stops should be used.

The regular ground glass of the Rollei is not used during this operation.

THE MAMIYAFLEX C2, C22, C220, C3, C33, C330

These cameras have sufficient bellows extension to make 1:1 copies, approximately, when the 65mm lenses and full extension are used. About the same magnification can be obtained with the Mamiya 80mm lenses by adding a pair of +3 closeup lenses, one mounted on the upper and one mounted on the lower lens.

For parallax correction Mamiya offers a deluxe rackover device called the Paramender. The amount it shifts the taking lens so that it occupies the relative position formerly occupied by the viewing lens is precisely calculated for the Mamiyaflex model used.

The 1:1 ratio possible with the Mamiyaflex and 65mm lens, or 80mm lens with +3 closeup lenses, is good for making copies of 2¼" square slides.

Even greater magnifications for cropping and other purposes are possible by experimenting with stronger closeup lenses.

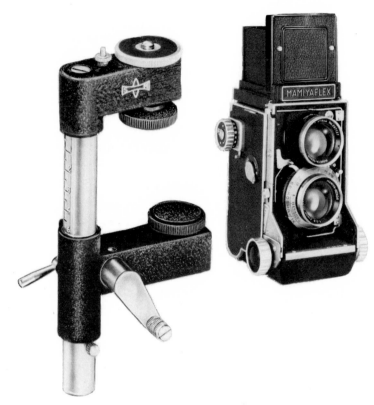

Mamiyaflex C2, C220, C3, C330 have interchangeable lenses, long copying bellows. Shown with Paramender mechanical parallax corrector.

3

Contact Duplicating

In contact printing the duplicate is the same size as the original. As the name implies, in making a dupe this way the original and sensitive material are in contact with each other, exposure being made through the original.

One of the advantages of contact duplicating is that it is possible to use very simple equipment. In many cases all you'll need is an ordinary printing frame, an exposing light, a darkroom, and chemicals, if you do your own processing.

Specialized equipment for contact printing is, of course, also available, and will be covered in this chapter. Duping stereo originals by contact avoids the introduction of optical distortions.

PRINTING FRAMES

The ordinary printing frame will be found convenient mostly for use with 2¼″ × 3¼″ and larger sheet sensitive material. Rollfilm material separated from its paper backing and 35mm film are not convenient to handle in the dark in an ordinary printing frame, because of excessive curl. You'll probably also find it inconvenient to work with strips of 35mm film originals for the same reason. Special printing frames described later on are better for this.

Although you'll usually want to duplicate one transparency at a time in an ordinary print frame, it is possible to do several smaller ones at a time on a large sheet of film. To prevent small transparencies from slipping around in the dark when inserting the sensitive material, hold them in place with small pieces of Scotch tape. For best results, when several transparencies are to be duped on one sheet of film, these should be of similar density and color balance.

While almost any kind of sensitive material may be used to produce dupes by contact, you'll find sheet Anscochrome Duplicating Film Type 6470, Agfa Duplichrome, or Ektachrome Duplicating Film convenient. They produce high color fidelity without the need for any special techniques. Tungsten lights, 3000 K and 3200 K, respectively, are needed. For convenience the light from an enlarger may be used for exposure. Filters for correction may be inserted in the color head of the enlarger, where present, or be used on the enlarger lens.

Where the enlarger head is equipped with an Ascor electronic flash tube, daylight type, Ektachrome Duplicating color films may be used to make excellent dupes. (See Chapter 6, "Enlargers and Projectors for Duping," for details about this Ascor device.)

No hard and fast rules can be given for calculating exposure. However, the exposure tables in Chapter 10, "Film, Light, Exposure, and Processing," may be used as a basis.

Duplicates can also be made on camera shooting films such as Ektachrome E-3, Type B, Anscochrome Tungsten, and Agfachrome CK with a tungsten light source. Another approach is to make an internegative on a sheet film material such as Ektacolor Type L, from which color transparencies are made either in same size or enlarged on Ektacolor Print Film. Neither of these procedures is capable of producing top-quality dupes without special techniques such as color "masking."

Masking consists of making one or more black-and-white negatives by printing in contact from the originals. These negatives, which must be made under precisely controlled exposing

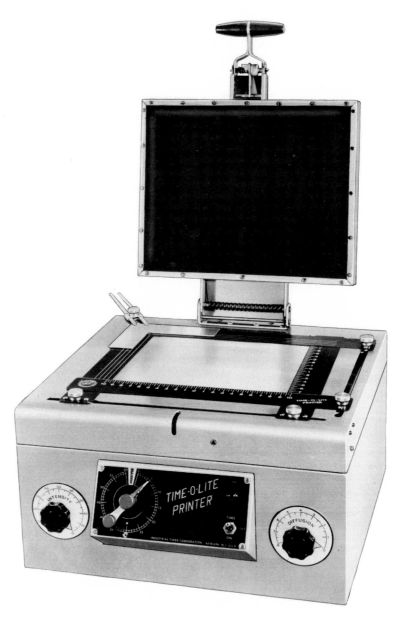

Time-O-Lite printer has built-in second exposure timer, voltage control, and light diffuser control. (Industrial Timer Corp.)

and processing conditions, are then bound in register with the original when exposing the dupe.

Registration of masks and originals will be facilitated by use of special register printing frames and register punches. The latter devices punch small holes in the film edges, the spacing of which corresponds to pins in the printing frame. Sources of supply for register printing frames include the Eastman Kodak Co., Rochester, N. Y. 14650, and Condit Mfg. Co., Sandy Hook, Conn.

Masks are of two kinds. One kind is used to preserve highlight detail and is therefore called a "highlight mask." The other kind, made by exposing panchromatic masking film by filtered light, is used to achieve color correction. For really precise masking work, a densitometer should be used.

Special literature on masking for slide duplicating may be obtained by writing the Sales Service Division of the Eastman Kodak Co.; Customer Service Dept. of GAF, New York, N. Y.; E. I DuPont de Nemours, Inc., Parlin, N. J.; Agfa-Gevaert, Teterboro, N. J.; and Ilford, Inc., New York, N. Y. 10023.

Kodak Ektacolor Internegative Sheet Film incorporates special highlight, contrast, and color correction masking layers. It can be used to make internegatives from color transparencies or photograph colored reflection copy.

It cannot be used successfully without the use and working knowledge of a densitometer.

SPECIAL PRINTING FRAMES

Where you wish to duplicate by contact short unmounted strips of 35mm film, or strips of 120 size transparencies, a special Multi-Printer printing frame, such as that made by M. P. Manufacturing Co., Brooklyn, N. Y., is recommended. This is made in two forms. One holds a single strip of film; the other prints either a full roll of 35mm or 120 on one sheet of 8″ × 10″ sensitive material.

The Multi-Printer holds the originals in place in non-slip grooves.

The important transparencies in each strip or group of strips should be of the same or similar density and color balance for best results.

For convenience, sheet Anscochrome Duplicating Film Type 6470 or Ektachrome Reversal Print Film, Type 5038, will be found to be excellent materials for use in the Multi-Printer frame handling 8″ × 10″ material. Short strips of 35mm Anscochrome 5470 or Ektachrome Reversal Print Film, Type 5038, can be used in the Multi-Printer.

SPECIAL CONTACT PRINTERS

When larger scale duplicating of 35mm slides is to be undertaken, contact printing with apparatus specially designed for this purpose is recommended. Such machines generally have some provision for transporting the film automatically, have a light-tight storage magazine for long rolls of film, and make duplicates from a variety of frame areas on 35mm film. In some machines, such as the Diafixo, the exposing light source is external and may be purchased as an accessory. In others, such as the Colorcontact and Praktomat, the light source is built in.

Colorcontact Printer

The Colorcontact Printer, distributed by Karl Heitz, Inc., New York, N. Y., can be used for making duplicates from 4 × 4cm (1⅝″ × 1⅝″, or Superslide), 24 × 36mm (1″ × 1½″, or standard frame), 24 × 24mm (1″ × 1″, or Robot), 18 × 24mm (¾″ × 1″, or single frame) transparencies, and other sizes. It can also be used for duping 23 × 24mm stereo slides (Realist and other brands) by purchasing an accessory five-sprocket drive. It is also useful for making slides from Kodacolor or Ektacolor negatives, Ektacolor Slide Film, and Agfacolor

negatives on Agfacolor Positive Film S. Mounted transparencies or filmstrips can be handled.

Basically, the Colorcontact consists of two parts. The lower portion or body contains a special 60-watt 2700 K color-corrected lamp, a filter drawer for 2″ × 2″ filters between lamp and film, a diaphragm in the lamphouse for regulating the light intensity, an outlet for an electronic interval timer, a light switch for transparency or negative inspection, and a push button for exposing. The upper portion consists of a removable cover with film advance knob, magazine holding up to 30 feet of film, sprocket drive with click stops coupled to film advance knob to transport film, lever for changing advance to correspond to slide

Heitz Colorcontact Printer dupes all size 35mm originals, has voltage control, filter drawer.

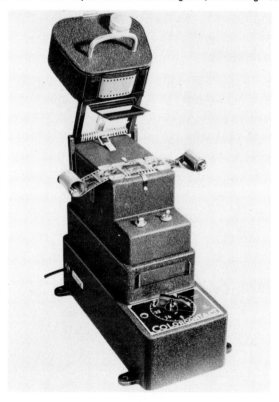

size being duped, and a window with a lined blind that opens automatically when the magazine is lowered for printing.

The 2700 K lamp in the Colorcontact may be brought into correct color balance for use with 2900–3000 K balanced color films, such as Anscochrome Duplicating Type 5470 and Ektacolor Slide Film, by inserting an 82B filter in the filter drawer. For Ektachrome Reversal Print Film an 82C filter is suggested. These filters are available in gelatin form from Kodak dealers. There should also always be an Ansco UV16P filter plus a heat-absorbing glass in the light system for Ansco Type 5470 film. When using Ektacolor Slide Film, substitute a 2B or CP2B filter for the UV16P.

The filters named should be considered a basic pack. In addition to these you may find other filters necessary to balance a particular film batch properly, or for some special effect.

Diafixo and Praktomat

Both of these are distributed by Burke & James, Inc., Chicago, Ill. 60604.

The Diafixo uses an enlarger light to expose the dupes; or a special lamphouse that illuminates only the area to be exposed. Its film magazine holds up to 100 feet of film. Slides 24 × 36mm, 24 × 24mm, and stereo size can be duplicated with the Diafixo.

The Praktomat magazine duplicates the same sizes as the Diafixo, holds 100 feet of film, and has its own built-in light source.

Kindermann (EPOI) Contact Printer

The light-tight housing holds eight feet of 35mm film. Windows for single- and double-frame transparencies are supplied. The unexposed film is transported automatically, one turn of the knob for single frames, two turns for double frames. Originals must be in unmounted form.

Burke & James Diafixo Printer holds up to 100 feet of film, dupes all sizes to 35mm.

GENERAL HINTS

For successful contact duplicating, absolute cleanliness is a must. Even the slightest bit of dust or dirt will be faithfully reproduced. This will show up later as giant size mars on the screen.

Dust and dirt can be kept down by maintaining an absolutely clean workroom and workbench. Shortly before operations begin, wipe the workbench with a slightly dampened cloth.

Glass surfaces should be cleaned thoroughly. Use of an anti-static cloth, such as that made by Faber or Rowi, will be found helpful in keeping glass surfaces dust-free. Shortly before exposure run an anti-static brush, such as an Alpha-Ray or Staticmaster, over the originals.

In most contact printing the emulsion side of the original is brought into contact with the emulsion side of the sensitive material. (Transparencies made this way should be viewed by looking through the emulsion side, and not through the back as is customary with originals exposed in the camera.) This printing procedure also effectively eliminates the Newton Ring problem, in so far as contact between original and sensitive material is concerned. However, where a glass is used in contact with the polished back of 35mm and other originals, the Newton Ring problem may crop up. To some extent this may be mas-

tered by placing a thin mask between original and glass. Where this is not possible, it is best to outfit the printing frame with anti-Newton-Ring glass. This is obtainable from dealers of the Eastman Kodak Co. A temporary expedient is to slightly abrade clear glass with talcum powder. This glass should be cleaned off thoroughly before being used for printing.

To insure overall sharp results the backs of printing frames should be properly sprung to make even contact. This is not always the case with inexpensive frames. Those made by the Eastman Kodak Co. under the heading Professional, by Burke and James, Inc., Chicago, Ill. 60604, and by Photo Materials Co., Chicago, Ill., have the necessary quality.

4

Duping with Fixed Focus Devices

Utmost simplicity and convenience in operation are the distinguishing characteristics of fixed focus copying devices. Duplicating *with even the simplest of cameras* is possible with the Lectro Duplicator. In general, the image sizes or magnifications possible with these are limited to same size or 1:1. A few fixed focus units, such as the Leitz Beoon and the Copying Unit for the Voigtlander Prominent, can copy at several fixed magnifications. Once attached to the camera and properly adjusted, they are ready for use with a camera loaded with film and set for the correct exposure.

For convenience in discussing fixed focus devices, let us divide them into the following categories:

Group I. Universal devices, such as the Lectro Duplicator. These are used primarily with non-interchangeable lens cameras or enlarged dupes with TLRs.

Group II. Devices are made for use with a specific interchangeable-lens camera. These include the Leitz Beoon, Pro-Tessar M for the Contaflex, Kodak Retina 1:1 Copying Kit, and the Copying Unit for the Voigtlander Bessamatic and Ultramatic.

Group III. Complete optical units for use with a variety of interchangeable-lens cameras include the Spiratone Dupliscope, Spiratone Duplivar, and the Miranda Slide Duplicator. The Dupliscope and Miranda make 1:1 dupes, while the Duplivar is adjustable for magnifications from 1:1 to 2.5:1. All have interchangeable adapters compatible with the "T" system so that they may be used with practically all 35mm SLRs.

Group IV. The Testrite Cinelarger. This differs from the other units discussed in this chapter in that it is a complete copying camera that delivers enlarged duplicates from 35mm or 828 transparencies on 620 roll film. Models for copying 8 and 16mm movie frames are also available.

GROUP I. UNIVERSAL DUPLICATORS

The Lectro Duplicator makes it possible for owners of even the simplest 35mm cameras to make 1:1 or same-size duplicates from 35mm slides, or portions of Bantam 828, Super Slides, and the 31″ × 31″ Kodacolor transparencies made from 2¼″ or 1⅝″ square Kodacolor negatives. It may also be used on a twin-lens reflex to make somewhat enlarged dupes on 120 film.

Basically, the universal duplicator consists of a slide holder at the front end which accepts transparencies in 2″ × 2″ slide mounts, an optical closeup lens system, and a means of attaching the duplicator to a filter adapter.

The *Accura VM Duplicator* plus a *Spiratone +20 Macrostigmat* combined makes up a duplicating device suitable for copying slides in 1:1 size with almost any 35mm camera equipped with a 50mm lens, although its primary use will be for cameras not having interchangeable lenses, nor the ability to use extension tubes. To combine the two, the VM Duplicator must be fitted with a 7-to-6 step-down ring. The series 7 portion of the step-down ring is fitted to the front end of the Macrostigmat. The Macrostigmat is then fastened to the camera, using

the lens fittings recommended by Spiratone, Inc., for your particular camera lens.

The *Lectro Duplicator,* made by Electron Development Co., Indianapolis, Ind., is of all plastic construction. It, too, is made in two models, one for use with 45 to 50mm lenses, and the other for 54 to 58mm objectives. These are furnished with threads to fit either series 5 or series 6 adapter rings. The optical system of the Lectro Duplicator is a two-element achromatic lens. It is attached to the camera lens in the same manner as the Accura Duplicator, as described above. Squaring the transparency with the edges of the film is done by not screwing the duplicator all the way home in the adapter ring. This will allow turning it to the left or the right to straighten out the slide. After squaring things up, a small piece of adhesive tape will keep the duplicator lined up. The Lectro Duplicator enlarges the slides slightly beyond 1:1 to compensate for differences in the dimensions of slide mount openings of varied manufacture.

GENERAL HINTS

Now for some general hints on the use of the Lectro and VM plus Macrostigmat duplicators. These incorporate rather powerful optical closeup lens systems. This is bound to affect definition if you insist on using large apertures in your camera lens. At openings of $f/16$ or $f/22$, however, the definition with these devices ranges from highly acceptable to excellent. The degree of excellence is dependent in large part on the quality of the original camera lens. The best definition will generally be experienced when the adapter is mounted as close to the camera lens as possible.

This is generally true when the recommended series adapter is used. In a few instances, it may be difficult to get the best focus when extra space between lens and duplicator is introduced by a step-up or step-down ring. Cut-off edges or vignet-

ting may also be introduced by the use of a step-up or step-down ring. There is also considerable danger of the corners of the image being cut off when these slide duplicating devices are mounted on deep-set automatic and preset lenses of certain single-lens reflex cameras. Lectro models and the VM plus Macrostigmat help to minimize this.

The instructions that come with the Lectro Duplicator recommend setting the camera lens at infinity and using the smallest possible stop to secure good definition. In a few instances, because of the peculiarities of individual cameras, you may find that the infinity setting doesn't give you sharp focus. To determine the best setting of the camera lens focusing scale, place a groundglass or stiff matte acetate in the camera focal plane. Check the focus visually with the camera shutter open at "T" or "B" (with a locking cable release), and the lens stopped down to $f/16$ or $f/22$. To see the image clearly with so small a stop, the camera-duplicator assembly should be close to a strong light. A jeweler's loupe will help you get critical focus on the groundglass. After determining which camera distance setting gives the best sharpness, note this fact on a piece of adhesive tape fastened to the body of the duplicator.

Enlarged Dupes with Twin-Lens Reflexes and Tele Lenses

When used on a 2¼" square twin-lens reflex, the image size is approximately 1⅜" × 1⅛". The exact size depends on which duplicator model is used, the actual mount opening size, and the focal length of the reflex camera lens.

With twin-lens reflex cameras, the duplicator should first be mounted on the top of the finder lens and the transparency edges lined up squarely with the edges of the finder frame. The duplicator is then transferred to the taking, or lower, lens to make the exposure. With a camera having bayonet filter mounts, use of a bayonet filter adapter will facilitate transferring the duplicator from finder to taking lens in the same rela-

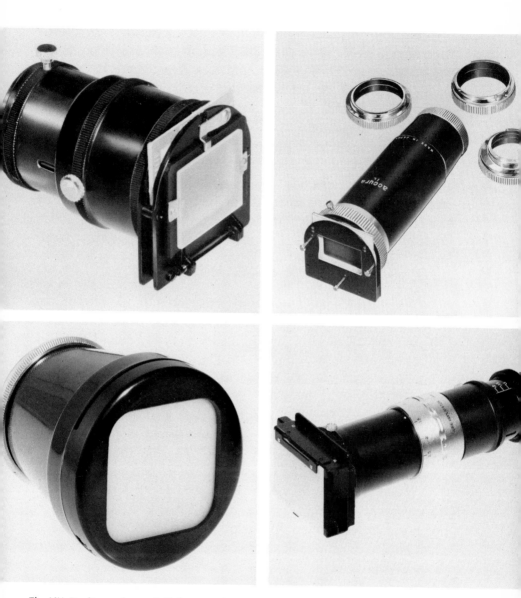

The VM Duplicator (upper left) fits on end of lens which is on an extension, or it may be mounted directly on a macro lens. Accura IL (upper right) has interchangeable rear flanges to fit practically all interchangeable-lens 35mm rangefinder and reflex cameras; makes 1:1 dupes. Lectro Duplicator (lower left) makes dupes even with simple 35's. Duplivar (lower right) is similar to Dupliscope by Spiratone, makes images from 1:1 to enlarged 2.5:1.

tive position. Bayonet filter adapters are made in both series 5 and series 6 sizes. Since the finder lens of twin-lens reflexes cannot be stopped down, the groundglass image may not appear very sharp. However, when the duplicator is transferred to the taking lens and this is used at its smallest stop, sharp images will generally result.

Lectro Duplicators make enlarged or cropped images from portions of slides when mounted on the telephoto lenses of interchangeable-lens cameras. The amount of enlargement is in direct relation to the focal length of the tele lens. Thus, with the Lectro Duplicator and a 100mm lens, the magnification is $2\times$.

HALF-FRAME SLIDES AND FILMSTRIPS

When the Lectro Duplicator is mounted on the normal lens of the half-frame Olympus Pen F single-lens reflex camera, the full area of a $1'' \times 1\frac{1}{2}''$ standard slide may be copied. The slide should be inserted into the Lectro Duplicator in the vertical position. It is also possible to use the VM plus Macrostigmat or Lectro Duplicators in a similar manner on other non-reflex half-frame cameras, provided these have a focal length lens of about 38mm. In this case checking focus and alignment of the slide will have to be done by temporarily mounting a groundglass in the focal plane of the camera.

If a filmstrip is to be made by copying a series of slides, these should all be of similar density and contrast. If this is not possible, run a test filmstrip through, noting the exposure (lamp distance) for each slide. Corrections can then be made on the next run-through.

GROUP II. UNITS FOR SPECIFIC CAMERAS

Except for the Pro-Tessar M for the Contaflex, these units usually consist of a short extension tube, a platform to hold the

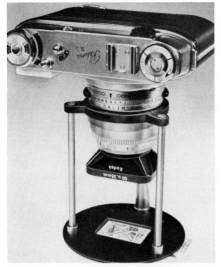

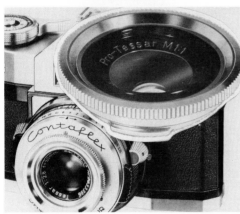
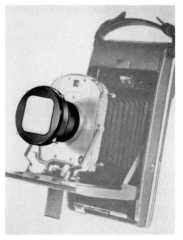

Units for specific cameras: Kodak Retina 1:1 Copy Kit (top left); Leitz BEOON (top right); special model Lectro for various Polaroid cameras (bottom right); and Zeiss Pro-Tessar M for Contaflex (bottom left).

camera, a focal frame, which acts as a finder, and rods or legs to locate the lens at the proper focal distance from the subject. In the Zeiss Contakop, Leitz Beoon, and Nikon Repro Copy Outfit, Model S, a focusing eyepiece is supplied which is used to replace the camera body on the unit temporarily. Focusing eyepieces

are used to make minor adjustments in focus necessitated by slight variations from the marked focal length of lenses and by differences in thickness among cardboard and glass slide mounts.

The *Contakop* (discontinued) is designed for use with Contax II, III, IIa, and IIIa cameras. It may also be used with Nikon S, S2, S3, and SP cameras, after some minor adjustment is made in the lens mount of the Contakop. This adjustment can be made by a camera repair shop. *It will not be made by Carl Zeiss, Inc.* Only one image magnification, 1:1, is possible with the Contakop using a 50mm Zeiss lens. For duplication, the slide may be laid on a light box and the Contakop placed on top of this. In other setups, the slide may be held under the focal frame by means of paper clamps. A focusing eyepiece, which temporarily substitutes for the camera body, is provided.

The *Leitz Beoon* (discontinued) is designed for Leica cameras and 50mm Leica lenses. It can also be used with other makes of camera having a Leica-type threaded lens mount, such as Leotax, Canon, and Nicca. Four image magnifications can be made— 1:1, 1:1.5, 1:2, and 1:3, having field sizes of 15/16″ × 1-7/17″ (24 × 36mm), 1-7/16″ × 2⅛″ (36 × 54mm), 1⅞″ × 2-13/16″ (48 × 72mm), and 2-13/16″ × 4¼″ (72 × 108mm), respectively. The larger field sizes will be found particularly useful for copying transparencies larger than 35mm. A focusing eyepiece is also provided.

The *Retina 1:1 Copying Kit* is designed for use with Kodak Retina IIIS, Retina Reflex S, and Reflex III and IV cameras. It consists of a short extension, +6 closeup lens, and a focal frame. Of all the units discussed in this group, it is the only one that has a holder for 2″ × 2″ slides at the focal frame. It can, therefore, be used conveniently not only for close-ups of small objects but to hold 2″ × 2″ slides in place with no makeshift arrangement needed.

Enlarged image from Testrite Cinelarger.

The *Zeiss Pro-Tessar M* is interchanged with a front component of the 50mm Zeiss Tessar lens of the Contaflex III, IV, Super, and Rapid cameras. No focal frame or stand is supplied with the Pro-Tessar M. The user must provide himself with these. Zeiss offers a special copying stand for the Contaflex. Other recommended stands are an enlarger stand minus its lamphouse, Testrite Copying Stand, and Rowi Copying Stand. In copying, the slide may be placed on a light box.

The *Voigtlander Copying Unit* (discontinued) for the Bessamatic and Ultramatic makes dupes at 1:1 and 2:1 ratios. For 1:1 magnification, a special 100mm lens is used in combination with extension tubes. For 2:1 magnification, the normal 50mm lens is added to the unit. Separate focal frames are pro-

Image size produced by the Lectro Duplicator on 2¼″ x 2¼″ twin-lens reflex.

vided for the 24 × 36mm (1″ × 1½″) and 18 × 24mm (¾″ × 1″) areas seen by the lens.

The *Nikon Repro Copy Outfit,* Model S, (discontinued) is for use with all the rangefinder focusing Nikon cameras. It may also be used with Zeiss Contax rangefinder cameras after some minor adjustment in fittings is made. This can be done by a camera repair shop. *It will not be done by Nikon, Inc.* With a 50mm *f*/2 or *f*/1.4 Nikkor lens, or the 50mm *f*/3.5 Micro-Nikkor with lens mount collapsed, magnifications from 1:1 to 1:20 are possible. In the 1:1 to 1:5 range, the outfit's own stand is used in conjunction with a series of focal frames. For other magnifications, a supplementary lens is attached and the unit mounted on a tripod or other support. A focusing eyepiece is used in the manner described above.

GROUP III. COMPLETE OPTICAL UNITS FOR INTERCHANGEABLE-LENS CAMERAS

Units in this group are the *Spiratone Dupliscope* and *Miranda Duplicator,* which make 1:1 duplications only. These are meant to replace the normal lens of your camera in much the same manner as a telephoto. Each unit has its own built-in specially corrected copying lens and a slide holder that can be revolved to line up the sides of the slide squarely with the film edges. By means of interchangeable "T" adapters, these units can be made to fit a variety of cameras. These include Exakta, Praktica, Miranda, Nikon, Nikon F, Canonflex, Minolta, Konica F and FS, Pentax, Contax, Leica, Canon, Olympus Pen F, and other 35mm SLRs. Similar units are sold under names such as Prinz, Soligor, Samigon, etc.

The *Spiratone Duplivar* is more versatile than the units described above. It too is a complete optical system, but it is able to make a continuously variable series of magnifications ranging from 1:1 to 2.5:1. It also uses "T" adapters for various SLRs.

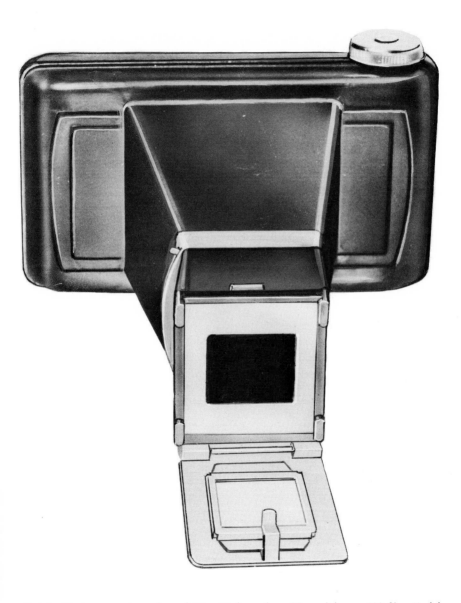

Testrite Cinelarger makes enlarged 2" x 3" dupes from 35mm slides on 620 film. Models are also available to copy single 8mm, Super 8, Single-8 and 16mm movie frames.

GROUP IV. THE TESTRITE CINELARGER

This is a complete copying camera. It incorporates its own copying lens, time exposure shutter, film chamber for 620 roll-film and holder for 2″ × 2″ slides. It makes eight exposures approximately 2¼″ × 3¼″. Other models of Cinelarger make 16 enlarged duplicates from 8mm, Super 8, Single-8, and 16mm frames on 620 film.

SOME OTHER COPYING DEVICES

There are a number of other gadgets useful in making copies of larger slide areas, or in photographing original material for titling.

Leitz BOOWU, which fits screw-thread Leica and similar cameras, consists of a short extension tube and four adjustable legs, which act as field frames. Magnifications of 1:4, 1:6, and 1:9 for areas of 4⅛″ × 5¾″; 5¾″ × 8¼″, and 8¼″ × 11⅝″, respectively.

The *BOWUM* is similar but fits M-model Leicas. Both use 50mm Leica lenses. Both are recently discontinued.

Proximeters, Auto-Ups, and similar devices are made in models to fit just a few coupled rangefinder cameras. They permit working as close as ten inches for a minimum field size of about 5″ × 7″. They consist of a closeup lens and an optical unit to extend range of rangefinder. Proximeters correct parallax.

Honeywell Pentax Copipod fits all models of the Pentax and can be used for copying documents, art work, photographs, and stamps. It has four calibrated, telescoping legs. It is used in combination with closeup lenses. Adapter rings for 46mm and 49mm diameter Pentax lenses are supplied. Disassembled, it fits into a small leather pouch.

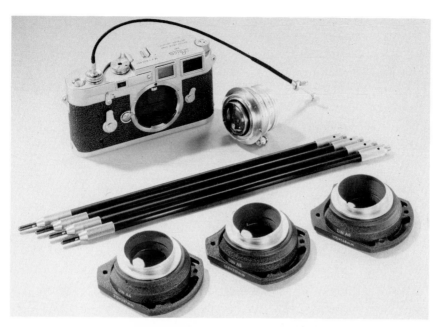

Leitz BOOWU is made in models to fit M and thread-mount Leicas. The legs place lens at proper working distance and frame subject. Objects in foreground are short extensions.

Kodak Retina Close Range- and Viewfinder slips into accessory shoe, and is used instead of the regular rangefinder.

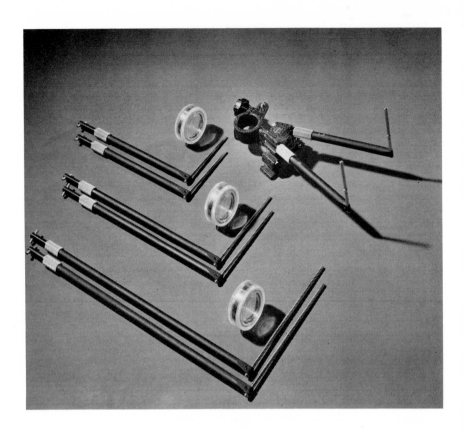

Kodak Retina Closeup Kit (above) uses closeup lenses for close focusing. L-shaped "focus guides" place camera at correct distance and outline area lens sees. At right, the kit is in use.

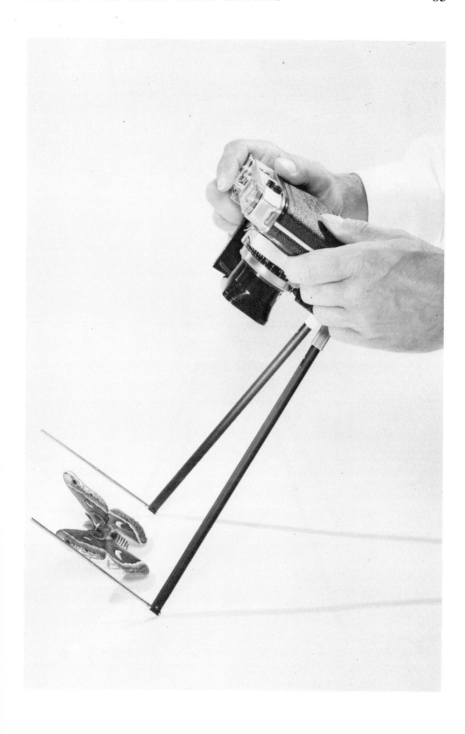

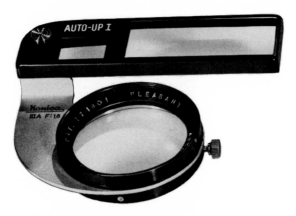

Konica Auto-Up I (above) allows you to focus from 40 to 20 inches from the subject. It is compensated for parallax. Pentax Copipod (below) may be used with any 35mm SLR having 46mm or 44mm lens threads.

5

Sliding Focusing Attachments

Basically, these consist of a platform, on the upper half of which are mounted a camera body and a ground glass. This latter is in the same focal plane as the film in the camera. On the lower part of the platform the lens is mounted under an opening.

In use, the ground glass is first positioned over the lens for focusing. The camera body is then moved into place and the exposure made.

Although the term "sliding" is used in the title, some devices of this nature use other movements to shift camera and ground glass. This is described later on under each individual device.

Like the reflex housing, the sliding focusing attachment provides parallax-free ground glass focusing. It has the advantage of a considerably lower price than a reflex housing of the same make. Sliding focusing attachments are used with the camera mounted on a stand or other support.

Closeup working distances are obtained by the use of closeup lenses, bellows extensions or tube in the same manner as described for single-lens reflex cameras, and reflex housings.

THE LEITZ FOCOSLIDE

The Leitz Company can be credited with offering the first device of this kind to the 35mm market and the only to survive.

Two Focoslides are offered. The Focoslide-M accommodates only Leica M1, M2, M3, M4, and MP, whereas the previous Focoslide accepts all screw-thread Leica cameras, regardless of model number. It will also take certain other cameras such as Nicca, Leotax, Tower, and Honor.

The current models of the Focoslide will focus from infinity to 1:1.1 when used in conjunction with the Repro Focotar lens and will focus still further with the addition of extension tubes. With other lenses attached, the Focoslide will focus from 50 ft. down to closeup ranges.

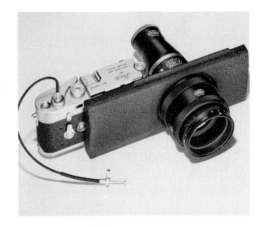

Leitz Focoslide in use on a Leica M3.

Exploded view of the Focoslide-M.

RATIOS—AREAS COVERED—DEPTH-OF-FIELD—EXPOSURE FACTORS

		ENGLISH SYSTEM Depth-of-Field in Inches						METRIC SYSTEM Depth-of-Field in Millimeters					EXPOSURE
RATIO	Area in Inches	f/4	f/5.6	f/8	f/11	f/16	Area in mm	f/4	f/5.6	f/8	f/11	f/16	FACTOR
1:20	18.9 x 28.4	4.41	6.18	8.85	12.1	17.7	480 x 720	112.0	156.8	224.0	308.0	448.0	1.1 X
1:18	17 x 25.5	3.59	5.05	7.17	9.94	14.4	432 x 648	91.2	127.7	182.4	250.8	364.8	1.1 X
1:17	16.2 x 24.2	3.22	4.50	6.43	8.85	12.8	408 x 612	81.6	114.2	163.2	224.4	326.4	1.1 X
1:16	15.1 x 22.6	2.86	4.02	5.72	7.90	11.4	384 x 576	72.5	101.6	145.1	199.5	290.1	1.1 X
1:15	14.2 x 21.3	2.52	3.53	5.05	6.95	10.1	360 x 540	64.0	89.6	128.0	176.0	256.0	1.1 X
1:14	13.2 x 19.8	2.21	3.09	4.41	6.08	8.84	336 x 504	56.0	78.4	112.0	154.0	224.0	1.1 X
1:13	12.3 x 18.5	1.91	2.68	3.83	5.28	7.66	312 x 468	48.5	68.0	97.1	133.5	194.1	1.2 X
1:12	11.3 x 16.9	1.64	2.30	3.28	4.50	6.55	288 x 432	41.6	58.2	83.2	114.4	166.4	1.2 X
1:11	10.4 x 15.6	1.39	1.94	2.77	3.82	5.56	264 x 396	35.2	49.3	70.4	96.8	140.8	1.2 X
1:10	9.45 x 14.2	1.15	1.62	2.32	3.18	4.62	240 x 360	29.3	41.1	58.7	80.7	117.3	1.2 X
1:9	8.51 x 12.8	0.945	1.32	1.89	2.60	3.78	216 x 324	24.0	33.6	48.0	66.0	96.0	1.2 X
1:8	7.56 x 11.3	0.758	1.06	1.51	2.08	3.03	192 x 288	19.2	26.9	38.4	52.8	76.8	1.3 X
1:7	6.61 x 9.92	0.588	0.825	1.18	1.62	2.36	168 x 252	14.9	20.9	29.9	41.1	59.7	1.3 X
1:6	5.66 x 8.51	0.441	0.620	0.885	1.21	1.77	144 x 216	11.2	15.7	22.4	30.8	44.8	1.4 X
1:5	4.72 x 7.09	0.315	0.440	0.632	0.867	1.26	120 x 180	8.0	11.2	16.0	22.0	32.0	1.4 X
1:4	3.78 x 5.66	0.209	0.296	0.422	0.580	0.840	96 x 144	5.3	7.5	10.7	14.7	21.3	1.6 X
1:3	2.84 x 4.26	0.126	0.178	0.252	0.347	0.505	72 x 108	3.2	4.5	6.4	8.8	12.8	1.8 X
1:2	1.89 x 2.84	0.063	0.087	0.126	0.173	0.252	48 x 72	1.6	2.2	3.2	4.4	6.4	2.3 X
1:1.5	1.42 x 2.13	0.039	0.055	0.079	0.110	0.158	36 x 54	1.0	1.4	2.0	2.8	4.0	2.8 X
1:1.33	1.26 x 1.89	0.031	0.047	0.067	0.091	0.134	32 x 48	0.8	1.2	1.7	2.3	3.3	3.1 X
1:1	0.945 x 1.42	0.020	0.031	0.043	0.059	0.083	24 x 36	0.5	0.8	1.1	1.5	2.1	4 X
1.5:1	0.630 x 0.945	0.012	0.016	0.023	0.032	0.047	16 x 24	0.30	0.41	0.59	0.81	1.19	6 X
2:1	0.472 x 0.709	0.008	0.011	0.016	0.022	0.032	12 x 18	0.20	0.28	0.40	0.55	0.80	9 X
3:1	0.314 x 0.472	0.005	0.007	0.010	0.013	0.018	8 x 12	0.12	0.17	0.24	0.33	0.47	16 X
4:1	0.236 x 0.354	0.003	0.005	0.007	0.009	0.013	6 x 9	0.08	0.12	0.17	0.23	0.33	25 X
5:1	0.189 x 0.284	0.002	0.004	0.005	0.007	0.010	4.8 x 7.2	0.06	0.09	0.13	0.18	0.26	36 X
6:1	0.158 x 0.237	0.002	0.003	0.004	0.006	0.008	4.0 x 6.0	0.05	0.07	0.10	0.14	0.21	49 X
6.5:1	0.145 x 0.217	0.002	0.003	0.004	0.005	0.007	3.7 x 5.5	0.05	0.07	0.09	0.13	0.19	56 X
7:1	0.135 x 0.202	0.002	0.002	0.004	0.005	0.007	3.4 x 5.1	0.04	0.06	0.09	0.12	0.17	64 X
8:1	0.118 x 0.177	0.002	0.002	0.003	0.004	0.006	3.0 x 4.5	0.04	0.05	0.08	0.10	0.15	81 X
9:1	0.105 x 0.158	0.001	0.002	0.003	0.004	0.005	2.7 x 4.0	0.03	0.05	0.07	0.09	0.13	100 X
10:1	0.094 x 0.142	0.001	0.001	0.002	0.003	0.005	2.4 x 3.6	0.03	0.04	0.06	0.08	0.12	121 X
	Circle of confusion = 1/750 inch						Circle of confusion = 1/30 mm						

The above data are approximately correct for all cameras making 24 x 36mm (1" x 1½") pictures. (Courtesy E. Leitz, Inc.)

THE EXTREME VERSATILITY
OF THE FOCUSING BELLOWS II

This chart indicates the major combinations possible with this ultra-compact reproduction unit. Even greater image-magnifications than those indicated for the various lenses may, for example, be obtained by employing additional standard Leitz extension-tubes. An ideal device for general copying and extreme close-up applications, the Focusing Bellows II provides both the precision required by technical and scientific workers and the simplicity of operation desired by the amateur.

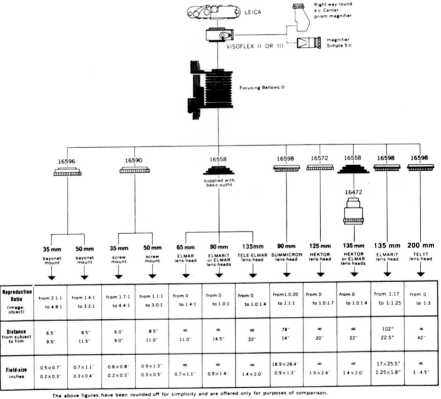

The above figures have been rounded off for simplicity and are offered only for purposes of comparison.

(Courtesy E. Leitz, Inc.)

A special feature of the Focoslide is the clear area in the center of its ground glass. In connection with an accessory 30× Leitz magnifier, exceedingly critical fine focus can be achieved, since an "aerial image" is observed which is free of the coarse grain of the ground glass. Other magnifiers include the standard 5× vertical wide-field type, the 90° 5× magnifier, and the 45° 4× magnifier. The latter two will be found most convenient for copying when the camera is on a stand. The 45° magnifier does not fit the Focoslide for screw-thread Leicas.

OTHER MODELS

Other sliding focusing attachments have been made in the past, principally for rangefinder models no longer being manufactured. In most cases, they are similar to the Focoslide, with variations to suit their cameras.

The Nikon Repro Copy Kit, Model P, accomodates the rangefinder Nikons S, S2, S3, and SP. The camera body is placed on a hinged platform, and swung into position after focusing. It permits magnifications of 1:17 to 1:1.

Canon Panta Closeup Device is designed for Canon rangefinder cameras, screw-thread Leicas, and similar cameras. The camera and ground glass are mounted on separate platforms. The Panta can take lenses of very short focal length.

6

Enlargers and Projectors for Duping

In our discussions of cameras and special slide duplicating devices, we are wont to overlook the enlarger's many capabilities in the field of slide duplicating. With proper handling this machine may be used to make enlarged dupes of almost unlimited magnification, be used as a light source in duping, or be converted into a copying camera.

The ideal enlarger for duping will be equipped with a filter drawer, or "color head." This places the filters (and sometimes the heat-absorbing glass used in duplicating) between the light source and the original. In this position there is no loss of definition, as may be the case when filters are placed below the lens. Another advantage is that inexpensive Kodak CP, Agfacolor CC, Ansco CC, or Spiratone plastic filters can be used.

Certain enlargers, such as the Simmon Chromega, Beseler, and Durst, have deluxe color heads in which turning three dials, one each for cyan, magenta, and yellow, gives any desired color balance.

Other desirable features are freedom from vibration when the head of the enlarger is at the top of the column and a high

72

Even inexpensive modern enlargers like Bogen (shown) have color filter drawer. Similar units are made by Spiratone, Ponder & Best, Sterling Howard, and many others.

quality enlarging lens. A cheap lens will do for occasional work, but for utmost definition a quality lens, such as a Schneider Componon, Kodak Enlarger Ektar, Wollensak Pro-Raptar, El Nikkor, Leitz Focotar, or Rodenstock Enlarging Lens, is a must.

ENLARGED DUPES

First let's take up the use of an enlarger in the normal manner in the making of enlarged dupes. While camera films such as Ektachrome and Anscochrome Type B can be used for making enlarged dupes, the results usually will be found too contrasty unless a highlight mask is first made and bound in contact with the original.

Special sheet duplicating films such as Anscochrome Type 6470 and Ektachrome Duplicating Film require no masking generally and are more suited for this purpose. Their inherent contrast is low.

The Anscochrome 6470 material is balanced for 3000 K, which is the approximate color temperature of a 212 or 211 enlarger lamp. An Ansco UV16P filter is required in the lamphouse, as well as a heat-absorbing glass. Anscochrome 6470 is coated on heavy sheet film base. It may be processed in regular Anscochrome solutions for the same times and temperatures as other Anscochrome materials. It will be processed by Ansco or any other finisher that offers an Ansco sheet color film service. You can also process this film yourself.

Ektachrome Duplicating Sheet Film is balanced for 3200 K. Electronic flash may also be used if the proper filters are placed in the enlarger lamphouse. Ektachrome Duplicating Sheet Film is coated on a thin base and requires special hangers for processing. FR and Yankee tanks will handle this and the Ansco material in sheets to 4″ × 5″. Processing is in Ektachrome E-4 chemicals. *This film will not be processed by the East-*

Deluxe Agfa (above) and Omega (below) color heads give desired filtration by turning three color dials. Agfa head is shown on Beseler machine.

man Kodak Co. It can be processed by custom color finishers, or you can do processing in your own lab.

Another approach to making enlarged dupes is to substitute a special electronic flash unit for the regular light source and work with daylight sheet color film, Type 6470 or EK Sheet Dupe with appropriate filters. Such a special unit is supplied by the American Speedlight Corp. for use on Simmon enlargers.

An Ascor Continuous Light Adaptor is used with this unit to flash the tube 120 times per minute. This gives the appearance of continuous light, making focusing possible. For actual exposure a single flash is usually given, although continuous light operation may be employed with small apertures to handle originals requiring dodging or burning in. Actual exposure recommendations cannot be given here, since too many factors are involved, including which Ascor power pack is used. Such data is contained in the literature available from the American Speedlight Corp.

Electronic flash is especially suited to commercial work where consistent color quality and cool operation are desired. The short flash duration helps minimize blur due to equipment vibration, and the soft quality of the light makes for a minimum of contrast shift when camera films are used in duplicating.

A third approach to making large transparencies is to shoot the original scene on a negative color film, such as Kodacolor-X, Ektacolor, Agfacolor CNS, Fuji N100, Sakura N100 or Dynachrome NM64. Transparencies are made from Kodak negatives, using sheet Ektacolor Print Film. For this material the light source should be a 211 or 212 lamp, plus a heat-absorbing glass and a Wratten CP28 or 2B filter. Ektacolor Print Film is processed in Kodacolor C-22 chemicals. For special immersion times, it is best handled by you or by a custom lab. *Ektacolor Print Film is not processed by Kodak.* Ektacolor L and Ektacolor Internegative sheet films may also be used. Data on the making of such internegatives may be obtained by writing the Sales

Ascor electronic flash unit for Omega enlargers.

Service Division, Eastman Kodak Company, Rochester, N. Y. Agfacolor negatives are printed on Agfacolor Positive S film. This is available in sheets as well as in 35mm rolls. Exposure is to tungsten light, and special processing solutions are needed. Full data on this is available from Agfa-Gevaert, Inc., Teterboro, N. J.

As the handling of sensitive material when making enlarged dupes will be in total or almost total darkness, some

hints about this are in order at this time. First of all, memorize the position of objects so that you will be able to find them with the lights off with a minimum of fumbling. Easels should be of a type that can be loaded easily in the dark. A good plan is to employ filmholders with the appropriate material. One holder should be provided for focusing, with slide withdrawn and a piece of white paper in place of film. This is laid in the corner of an easel for focusing and composing. For the actual exposure a loaded holder is substituted.

Where a safelight is recommended for a particular color film, this may be used to illuminate timer dials, but should not be allowed to fall on the sensitive material during handling, or fog may result.

Films should be handled by the edges only to prevent mar from fingerprints.

USING LAMPHOUSE AS LIGHT SOURCE

A novel approach to slide duplicating is to use the head or lamphouse of the enlarger to hold the transparency and filters, and project an image into a camera.

Where hot tungsten lights are used with Type A or B and special duplicating films, an enlarger lamphouse will keep slides much cooler than the improvised light box that is usually used with these sources.

One way to do this is to place a single-lens reflex camera with lens removed on its back and project the image from the enlarger lens into it. The camera should be raised on a block of wood to a height at which it is convenient to operate the film advance lever. The image is most easily observed in cameras having provision for use of a waist-level finder. Where this is not available, a right-angle finder should be used. The makers of the Honeywell Pentax, Konica Auto Reflex, Minolta SR and other cameras supply these for their own cameras. These permit con-

venient viewing and focusing when the camera is lying on its back.

In the method just described a 1:1 image can be obtained only if the extension inherent in the enlarger's bellows is long enough. Otherwise, enlarged or cropped duplicates will result. Solutions to this problem include use of a shorter focal length lens or the use of accessory long bellows "reducing attachments" supplied by some enlarger manufacturers. (The latter will be found useful also in making reduced duplicates from larger transparencies.)

In the method just described the actual exposure must be made in a totally dark room to prevent light other than the enlarger's from reaching the film and fogging it.

An alternate method, which does not require a dark room, is to use the reflex camera's own lens pointed up at the transparency in the lamphouse. Extension tubes or bellows are used in the normal manner to get the desired image size. This method is most feasible in those enlargers having removable lensboards, which leave a relatively large opening through which to point the camera lens. Where the opening is small, as is the case with enlargers in which the lens only can be unscrewed, the camera lens must be placed close to this opening to prevent image cutoff.

In both methods described, approximate exposures will be found in the exposure tables in Chapter 10.

In Chapter 8, "Duping Slides in Quantity," there is a discussion on using an enlarger in combination with an identification camera magazine.

CONVERTING AN ENLARGER INTO A DUPING CAMERA

A number of enlarger manufacturers, including Simmon, Beseler, Durst, Opemus, and Testrite, supply attachments in which a groundglass focusing camera back is substituted for the

lamphouse. These usually employ either 2¼″ × 3¼″ or 4″ × 5″ sheet film, making this sort of arrangement suitable for large dupes. In a few instances the entire assembly may be removed from the enlarger post and mounted on a tripod for use in the same manner as an ordinary camera. When this is contemplated, or in any situation where short exposures must be given, the enlarger lens must be removed and one with a shutter substituted. Relatively long exposures, however, may be made with the regular enlarger lens by turning the exposing lights on and off. Electronic flash exposures may also be made without a shutter. The room or focusing lights in a copying light box are first turned off. The slide of the 2¼″ × 3¼″ or 4″ × 5″ holder is then withdrawn and the flash set off by the "open flash" method.

USING A SLIDE PROJECTOR

A camera can be used to copy the image projected on a matte white screen in order to make duplicates. The camera should be placed as close as possible to the axis of the projector lens in order to avoid perspective distortion, or keystoning. By selecting various camera distances, or changing the image size on the screen, you can do cropping and special composing.

Some workers have produced interesting effects by substituting pale tinted matte cards for the white screen, thus getting either color correction or purposeful creative color changes.

The light of a projector lamp is approximately 3200 K, making it suitable without filtration for use with Type B color films, such as GAF T/100 Color Slide and High Speed Ektachrome, Type B. For other color film and filter combinations for a 3200 K lamp light source, see the chart in Chapter 10, "Film, Light, Exposure, and Processing."

An alternative method of working is to use a rear projection screen. A small screen suitable for amateur use is supplied by Spiratone, Inc., New York, N. Y. Kodak also supplies rear

projection screen materials for this purpose, as well as litera-
ture on how to build a rear projection cabinet. Write Kodak's
Sales Service Division pamphlet T-47. Other sources of rear
projection screens include Polacoat, Inc., Blue Ash, Ohio; Raven
Screen Corp., New York, N. Y.; and Edmund Scientific Co.,
Barrington, N. J.

Exposure can be calculated by taking reflected light read-
ings directly from the screen.

CONTRAST

Since there is no silver image in color films as we know
them today, choice of a condenser or diffusion light system in an
enlarger will have little effect on the contrast of the final color
image or duplicate. There are, however, some differences in re-
sults that should be pointed out.

Even though the contrast of the dye images is not affected,
the contrast of solid objects such as dust, fingerprints, and

Arrangements for copying slide
from projected screen image.
(See text.)

IMAGE ON SCREEN

CAMERA

PROJECTOR

smudges is affected by the choice of a condenser or diffusion system. A condenser system will tend to emphasize these, whereas a diffusion system will tend to suppress their effects.

If trouble from dust is a particular problem in your situation, consider changing from a condenser system to a diffusion type. Where this is not available commercially for your enlarger, it may be improved by placing a sheet of opal glass *under* the condensers.

In using a diffusion illumination system, check that the length of exposure falls within the reciprocity characteristics of the material you are using.

7

Making a Setup

The value of a good duplicating setup cannot be emphasized too strongly. Chances for repeatability of results are greatly enhanced when working distances and strength of light source are standardized. This also leads to less waste of relatively expensive color material.

In this chapter we'll discuss horizontal setups, vertical arrangements, light boxes, and a number of related problems.

HORIZONTAL SETUPS

In most cases horizontal setups may be considered temporary expedients, used in making an occasional dupe with fixed focus units such as those discussed in Chapter 4 and bellows copying devices discussed in Chapter 1. (An exception is the Pro-Tessar M for the Contaflex. This has no focal frame and is therefore best used in a vertical setup.) The procedure used is relatively simple and inexpensive. The camera is first mounted on a tripod. The lighting unit, either a tungsten lamp in a reflector or an electronic flash unit, is then mounted on a light stand or other support and placed directly opposite the location for the original. Where the unit used does not have a slide holder, the original should be taped to the focal frame. The disadvantage of a horizontal setup of the kind shown is that they are

Above, Exakta and Novoflex Bellows Copying Unit on Leitz Table Tripod. Below left, Nikon Slide Copier and electronic flash units mounted on stands. Below right, copying stands are helpful in making setups. This shows camera with Spiratone Duplicator and Spiratone stand.

not easily repeatable with any real degree of accuracy. This can be offset in part by carefully marking off the location of tripod legs and heights of light stands. Distances between light and slide should, of course, be measured as accurately as possible each time.

VERTICAL SETUPS

These have the advantage of easier placement of originals, lights, and camera in some sort of logical relationship to each other.

As in all other things, the kind of setup you'll make depends on how much you're willing to spend. You pays your money and takes your choice, as the saying goes. Relatively inexpensive upright stands suited for making duplicating setups, and that have enough height to allow copying large originals in titling and filmstrip making, are sold by Testrite Instrument Co., Newark, N. J., Spiratone, Inc., Flushing, N. Y., and Bogen Photo Co., Englewood, N. J. These are sturdy enough to hold even 4″ × 5″ cameras. Small copying stands suitable for use mainly with miniature cameras are the Rowi, Aetna-Optix Foldomat, Bogen, and similar units, often issued by camera makers for their own cameras. Counterbalanced types, making it easier to raise and lower the camera, are made by such firms as Burke & James, Inc., Chicago, Ill. 60604, and Kling Photo Corp., New York, N. Y. 10010. Some makes of enlarger in which the lamphouse is removable can also be converted into counterbalanced copying stands.

Uprights of enlargers such as the Leitz, some Durst models, and the Bogen Copying Stand have a friction drive. This permits precise movement of the camera up and down the post,

Kingdon Testrite Illuminated Slide Copier has holders for 2¾″x2¾″, 2″x2″, and 4″x5″ originals. Exposure is photoflood or enlarger incandescent light, focusing by two miniature, low-heat lamps. There is a space under the slide holder for the use of correction filters and a door in front for use of electronic flash.

Left, Alpha Macrostat may be used with Alpa and other cameras. Stores compactly, clamps to ordinary table in use. (Karl Heitz, Inc.) Right, Linhof Copying Stand and Lights are in a class by themselves. They are heavy-duty yet precisely controllable. May be used with Linhof and other cameras. (Kling Photo Corp.)

and is an aid in getting sharp focus once the bellows or other extension unit is set for a given magnification. In stands of this type there is also little sidesway, making it easier to compose the image. The Leitz stand features a quick-release lever in addition to friction drive. Though primarily intended for Leitz equipment, any camera repair shop can adapt it for use with other cameras at small nominal cost. For extra heavy, large cameras such as 4″ × 5″ view and press types, the Linhof copying stand is recommended. It is also useful where extra stability is a must.

The Durst and Bogen stands can be used with any camera having a ¼″ × 20″ tripod thread.

LIGHT BOXES

Despite the plethora of slide copying units, bellows extensions, and other related paraphernalia, at this writing there is

just one popularly priced light box made for use in slide duplicating. This is the Kingdon Duplicator made by Testrite Instrument Co., 135 Monroe Street, Newark, N. J. 07105.

The Kingdon Duplicator is of all-metal construction. Holders are provided for metal or glass mounted slides with outer dimensions of 2″ × 2″, 2¾″ × 2¾″, and 4″ × 5″ inches. A novel feature of the Kingdon Duplicator is the provision for insertion of filters between light source and original via a space between the opal glass and the slide, which can accommodate up

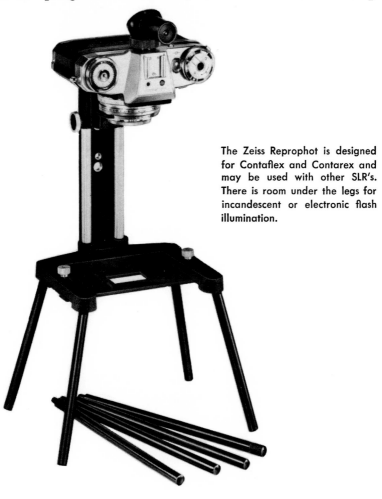

The Zeiss Reprophot is designed for Contaflex and Contarex and may be used with other SLR's. There is room under the legs for incandescent or electronic flash illumination.

to three 2¾" square glass slide binders. These are used to hold the correction filters. It is also possible to utilize the space provided for texture screens, vignettes, or a larger number of thinner filter holders.

Focusing and exposure with the Kingdon Duplicator are done by tungsten lamps. Separate focusing and exposing lamps are provided, each on separate electrical switches. The focusing lamps, controlled by a toggle switch on the front of the duplicator, are a pair of low-wattage 115V clear lamps. The exposing lamp (a No. 1 photoflood is recommended by the maker) is controlled by a hand switch at the end of a short electrical cord. Since the exposing light is turned on just before and immediately after exposure, serious overheating can in many cases be avoided.

Although the maker of the Kingdon Duplicator recommends a No. 1 flood, a variety of tungsten lamps may be substituted for special purposes. The No. 1 flood works well with Kodachrome II, Type A. For High Speed Ektachrome, Type B, Ektachrome Reversal Print Film, and GAF T/100 Color Slide Film, a 250-watt 3200 K lamp is used. For Anscochrome Duplicating Film Type 5470, Agfacolor Positive Film S, and Ektacolor Slide Film, a 211 or 212 enlarger lamp is used. With appropriate filtration enlarger lamps may be used to expose all these films, which results in a tremendous reduction in heat.

A basis for exposure may be determined by placing the cell area of an exposure meter in contact with the slide being copied. A contact printer, such as the one manufactured by Brumberger Sales Co., Brooklyn, N. Y., or similar machines may be used to handle originals larger than those accommodated by the Kingdon device. The clear glass is removed and replaced with an opal glass. A white 40-watt lamp for focusing replaces the red pilot lamp. A small electronic flash unit mounted inside the printer may be used to expose daylight film. You may have to drill a hole in the side of the printer to permit power and flash connecting cords to enter. If desired, 211 or 212 enlarger lamps may be used to make the exposure on Anscochrome Duplicating Film Type 5470, Ektachrome Reversal Print Film Type

Suggested design for heavy-duty illuminator suitable for professional operation. (Designed by George Ward of Photo Tech Service, Denver, Colo. Photo courtesy P.M.I. Magazine.)

5038, or Ektacolor Slide Film. These are placed in the sockets normally occupied by the regular low-wattage exposing lamps for contact paper. Just before exposure, the exposure button, normally depressed by lowering the platten, is actuated. Where 211 and 212 enlarger lamps are used, position a heat-absorbing glass and UV16P filter for Ansco (GAF) materials, or a CP2B filter for Kodak materials, under the opal glass.

PLACEMENT OF FILTERS

Since filters are used extensively for both creative and corrective purposes in slide duping, it's important for us to discuss their location in various copying setups.

Tungsten lamp is used for focusing, is turned off when electronic flash (right) is used for exposure in this homemade unit.

Electronic flash units may be laid on baseboard and camera setup mounted on stand. Where copying device has no light diffuser, place opal glass across flash reflector.

Wherever possible, filters should be placed between the original and the light source. In this position there is no interference with the optical performance of the lens used to form the image. It is also possible to use the less expensive acetate Ansco CC, Kodak CP, and Agfacolor filters, rather than gelatin Kodak CC filters, which are somewhat more expensive. Many odd, but not necessarily predictable results may also be obtained by use of colored stage gelatins. In copying setups using a tungsten enlarger lamp, a UV16P for Ansco, or a CP2B for Kodak, materials is usually included, as well as a heat-absorbing glass. Wherever possible, place the filter between the heat-absorbing glass and the original to protect it from the direct heat of the lamp.

The conditions outlined so far are easy to meet in enlargers having a color head. (See Chapter 6, "Enlargers and Projectors for Duping.") They are also present in such devices as the Honeywell Repronar, the **Bowens Illumitran**, (see Chapter 8) and the Heitz Colorcontact Printer (see Chapter 3).

Certain fixed-focus copying devices, such as the Lectro, let you place a series size filter between the unit and the filter adapter used to fasten it to the lens. In the Spiratone Dupliscope, Duplivar, and Miranda duplicators, there is a recess in front of the slide holder for series 7 filters. When more than one filter is needed, this can be done by using a retaining ring between filter adapter and the duplicator. In some cases, this may cause vignetting, unsharpness, or both. You can check this by pointing the duplicator at a strong light source and closing down to the smallest stop. If corners are cut off or the image isn't sharp, go back to using a single series filter only. However, you can use more than one filter if they are acetates or gelatins cut to size to fit the filter adapter.

In other setups where no filter holder is provided, and where electronic flash is the light source, large size inexpensive acetate Kodak CP, Ansco CC, Spiratone CC, and Agfacolor filters are used on the reflector. Other filters, such as conversion and light balancing, may be of the Kodak gelatin variety. Some of the newer small units have reflectors taking reasonably small filters.

Simmon D2 negative carrier for 2″ x 2″ glass- or cardboard-mounted slides is useful for building onto lightbox as holder for slide copying. (Kling Photo Corp.)

Where it is impossible to place the filters between light and transparency to be copied, and no other filter holder is provided, you may use Kodak gelatin or Agfacolor filters in front of the lens. These may be attached using a series-size filter adapter ring plus a Kodak Gelatin Filter Frame Holder. While gelatin filters affect definition the least, it's still a good idea to limit yourself to a maximum of three clean gelatins at a time to prevent undue definition loss and image degradation from reflections from filter surfaces. *Do not use acetate filters, or stage gelatins in front of the lens if the sharpest results are desired.* It is also well to remember that you will lose definition and color saturation by using scratched, dirty, or otherwise damaged filters in front of the lens.

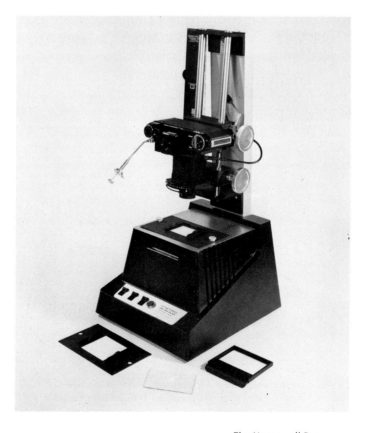

The Honeywell Repronar.

8

Duping Slides in Quantity

When dupes are to be made in larger than normal quantities, as for photofinishing or audio-visual purposes, procedures must be followed carefully and adequate equipment used. The trial-and-error methods used in ordinary work generally lead to inferior results, waste of time, and waste of costly materials, or all three.

Although any high quality camera may be incorporated into a self designed setup, as explained in Chapter 7, "Making a Setup," this section will be devoted mainly to equipment of a special nature. To be discussed also will be the purchase, handling, filtration, exposing, and processing of film in quantity.

THE HONEYWELL REPRONAR

The Honeywell Repronar ranks as the first popularly-priced completely-integrated 35mm slide-copying device to reach the U. S. market. Its cost is about that of a first-class enlarger, or that of a good quality single-lens reflex camera.

The Repronar makes 35mm dupes from any size 35mm original as well as other sizes up to and including 2¼" × 2¼". The magnification range extends from 0.5:1 to 4:1. This range is adequate for reductions of larger slides or cropped blowups of sections. Attachments are also supplied for the making of film-strips.

The Repronar is ideally suited to the small photofinisher or commercial studio having occasion to make slide duplicates fairly frequently. Where very large scale production is contemplated, the normal 36-exposure capacity of the Repronar may be considered too small, necessitating frequent, time-consuming reloading. This problem may be solved by having a special, custom-built, 100-ft. capacity magazine installed. This is manufactured by Honeywell.

In addition to its commercial uses, the usefulness of the Repronar has proved highly popular with advanced amateurs and with camera clubs. Its flexibility and ease of handling allow these workers, as well as creative professionals, to give full expression to their talents and imagination.

An outstanding feature of the Repronar is the fact that fully pre-tested exposure information is supplied for a great variety of reversal and negative color films, as well as for a number of special black-and-white emulsions. Suggestions for the use of filters with various color films are also given in the Repronar instruction book. This exhaustive little volume also gives suggestions for processing and contrast control, the creation of montages and special effects, and the use of the Repronar for filmstrips and for copying opaque subject matter.

Basically, the Repronar consists of an upright on which is mounted a Honeywell single-lens reflex camera with built-in long bellows and a 50mm $f/3.5$ Repronar copying lens. Alongside the camera is a scale that shows at which magnification you are working, and gives the diaphragm setting for that particular magnification and a normal transparency. The Repronar instruction book gives data on how to correct for underexposed or overexposed originals. The scale bar on the latest Repronars can be set for a film speed value furnished by Honeywell. If you own an older machine that has these films engraved on the scale bar, then consult the table on page 96 to calculate exposure values for the new film varieties. In use the lens standard is first set so its pointer is opposite the desired magnification figure on the

lower portion of the scale. The camera body is then moved until its pointer is opposite the same magnification figure on the upper scale section. Fine focus is accomplished by turning the camera travel knob and observing the image on the groundglass through the magnifier. After fine focusing, the camera body standard is locked into position. Magnifications in between those shown on the scales may also be used.

The lower portion or base of the Repronar contains a tungsten lamp, used for focusing, plus a special Honeywell Repronar electronic flash unit for making the actual copying exposure. During actual exposure, the tungsten lamp is automatically shut off. Above the lamps is an opal diffusion glass. Under this glass is a slot for the filter holder. This accommodates 3″ × 3″ gelatin filters as well as the 2″ × 3″ glass filters supplied by Honeywell. These latter are a UV-17 for Ansco Daylight Type films and an 81A for Kodak Daylight Type materials. Three slide holders come with the Repronar. One holder is sufficient for 2″ × 2″ slide mounts, another is for 2¾″ × 2¾″ mounts, and a third holder is used for 2″ × 2″ mounted slides in the making of single-frame filmstrips. In normal use the slide holders are held in place by two set screws. Where the original must be placed off-center, as in cropping, the slide holders are held in place by two magnets. The filmstrip holder is generally used locked in place, once a setup has been made. This is used for making single-frame filmstrips from double-frame 35mm slides. In addition to the slide holders, a filmstrip duplicating assembly is also supplied with the Repronar, which is used to make duplicates of already existing filmstrips.

TENTATIVE EXPOSURES FOR REPRONAR (NEXT PAGE)
Older Repronars have exposure scales for now discontinued color films. A new model scale bar, which is adjustable for various films, is now available as an accessory. However, if you like, you can get results using the following table with the old bar. The following data are based on preliminary tests by me. They are not to be taken as final, but simply as a guide to exposure with various films.

FILM	FILTER	EXPOSURE
Agfachrome CT18	UV-17	One stop less than Ektachrome scale
GAF 64 Color Slide	UV-17	One stop less than Ektachrome scale
GAF 200 Color Slide	UV-17	Three stops less than Ektachrome scale
Ektachrome-X	81A	One to 1½ stops less than Ektachrome scale
Kodachrome II	81A	Ektachrome scale
Kodachrome-X	81A	One stop less than Ektachrome scale
Dynachrome 64	81A	One stop less than Ektachrome scale

THE BOWENS ILLUMITRAN

The Bowens Illumitran is a unique slide copying device whose versatility is limited only by the imagination and creativeness of the photographer who owns it. It is the first popularly priced professional slide duping unit in which a photoelectric cell is used to determine correct exposure for the dupe. It is also the first unit of this type that lets you use any SLR from half-frame to 4″ × 5″ and press and view cameras. All originals from 35mm to 4″ × 5″ sizes may be copied.

Basically, the Illumitran consists of a light box and an upright bellows stand unit. The light box contains two tungsten carriage lamps, which are used for focusing and for measuring exposure, and an electronic flash unit for making the actual exposure. In use, a test to determine a basic f/stop exposure for a particular film and a "normal" original must first be conducted. To do this, the carriage lamps are lit, the normal original is placed into the slide holder, and the photocell (seen at the far left) is swung into place. A 1:1 magnification should be used. The large intensity control knob is at the bottom right with dots matching. The trimming knob under the meter dial is now turned to the left or right until the needle comes to zero. Next the camera is loaded (a slow or medium speed film is recommended), and a series of exposures starting at the smallest opening and going to f/5.6 via half-stops is made, using the flash. The film is now sent to the lab. The film should be re-

turned as an uncut strip from the lab. It is now examined to see at which f/stop the density of the dupe is closest to that of the original. This is the basic f/stop to be used in further duping at 1:1 with that film. (Critical workers having to make many dupes will, of course, wish to test individual emulsions.) To dupe slides that are denser or thinner than the "normal" slide you've selected, proceed as follows: Place the original in the slide holder, swing the photocell into place, and turn the large intensity control knob to the right or left until the needle is at zero. Turning the intensity control knob simultaneously raises and lowers the carriage lights and the electronic flash to alter the exposure level. (This method has the advantage that no

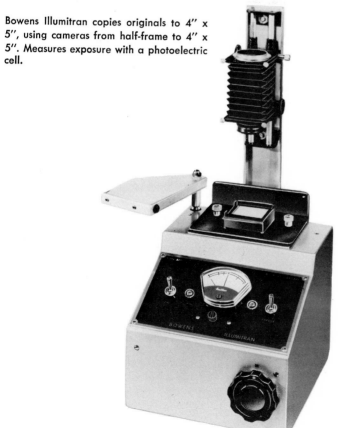

Bowens Illumitran copies originals to 4" x 5", using cameras from half-frame to 4" x 5". Measures exposure with a photoelectric cell.

change in electrical characteristics takes place as when transformers are used to change light intensity. The latter method can cause changes in flash duration and, consequently, changes in color balance of the dupe.) For special effects you can under- or overexpose by setting the needle at one of the plus or minus positions on the dial. For magnifications other than 1:1 use the following table.

Exposure for Higher Than 1:1 Duping with the Illumitran

Ratio of reproduction	Factor X	F/stop increase
1:1	1	none
1.5:1	1.25	⅓
2:1	2.25	1⅓
2.5:1	3	1½
3:1	4	2
4:1	6.25	2⅔
5:1	9	3⅓
6:1	12.25	3⅔
8:1	20.25	4½
10:1	30.25	5

The information so far has centered around slides that have a normal or average distribution of densities. In the course of your work, you will, of course, run into excessively contrasty slides, flat originals, off-color originals, small, light areas, and small, dark areas surrounded by dark or light, respectively. All of these can be handled in a rational manner with the Illumitran by following the directions in the well-written instruction book that accompanies the unit.

For corrective or creative work, filters may be placed under the diffusion plate in each slide holder. The 2″ × 2″ holder will accept 2″ × 2″ gel or mounted filters. For slides no larger than 24 × 36mm, a series 8 filter may also be used. By measuring the light with the filter in place, correct filtered exposure is easily achieved, without recourse to filter factor tables.

More data on the Illumitran may be obtained from Bogen Photo Co., Englewood, N. J. 07631.

THE LEITZ REPROVIT

A full description of this versatile unit will be found in the chapter on filmstrip making. For use in duping, the focusing lamphouse is removed and a Focoslide-type ground glass is substituted.

For duping, the Reprovit has the advantage of great rigidity for relatively vibrationless operation, and ease in handling due to the counterbalanced head, which is raised and lowered by friction drive. The rackover from camera to groundglass, which is described under Focoslide in Chapter 5, is smooth and fast in operation.

Perhaps the greatest advantage of the Reprovit as an investment is the opportunity to use this not only for slide duping, but in titling, filmstrip making, and in general copying of originals up to 16½ " × 25". It can also be used in microfilming, photomicrography, and macrophotography.

CAMERAS WITH LARGE CAPACITY ACCESSORY MAGAZINES

Included in this category are cameras such as the Topcon, Nikon F, Praktina, Alpa, and Robot. On copying stands, as

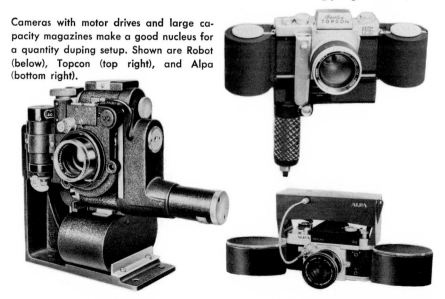

Cameras with motor drives and large capacity magazines make a good nucleus for a quantity duping setup. Shown are Robot (below), Topcon (top right), and Alpa (bottom right).

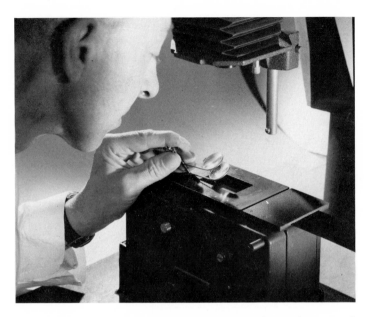

Identification camera's 100-foot magazine and enlarger make good quantity dupe setup. (Photo courtesy GAF.)

supplied by each maker or other firms, these become instruments well suited to large scale duping, where reloading frequently, as is the case with 20- and 36-exposure cartridges, would be extremely inconvenient.

The accessory magazine for the Nikon F camera has a capacity of 50 feet. The magazine for the Praktina has a capacity of 50 feet, while Robot magazines are available to hold 30 and 200 feet. The Alpa magazine holds 100 feet, the Topcon, 33 feet.

PURCHASE OF FILM IN LARGE QUANTITY

In large quantity operations, the cost of color film often can be the difference between profit and loss. For this reason color films will be purchased in bulk rolls of 100 feet and longer. It should be noted at this point that 100-foot rolls can be conveniently bulk-loaded into empty cartridges using the Watson 66 Loader, distributed by Burke & James, Inc., Chicago, Ill. 60604, or the Lloyd Loader made by Lloyd Mfg. Co., Houtzdale, Pa.

The Watson Loader has the advantage of being able to take 100-foot rolls on metal camera spools and has a frame counter. Also, in the Watson loader the film doesn't pass through felt. Recent new bulk loaders are the Loadette and Uniphot, which you may see on dealer's shelves. In the Lloyd and Uniphot the film passes through a felt light trap and only ordinary cartridges can be reloaded.

Empty used cartridges may be obtained from your local photofinisher or be purchased in packages of eight fresh ones from GAF dealers, Spiratone, Inc., New York, N. Y. 10001, or Uniphot, New York, N. Y. 10001.

The least expensive bulk films commonly available for duplicating purposes are Anscochrome Duplicating Film Type 5470 and Ektachrome Reversal Print Film Type 5038. The cost of these is about one-third of that of camera shooting film, when both are purchased in 100-foot rolls.

Most of the color films normally available for camera use are available in bulk form. The actual saving by buying in bulk can be considerable. The exact amount will, of course, depend on the price structure at the moment. A pro-pack of twenty-five 36-exposure cartridges of Anscochrome Duplicating film is offered by GAF.

Some mention has been made of the use of motion picture films for duping and filmstrip operations. Although this is quite feasible, it should be noted that very special exposing and processing equipment are often required. For instance, Eastman Color Negative Motion Picture Film has a remjet black backing, which can only be removed properly with special buffing machines. Also certain positive print stocks have their sensitive layers arranged differently from the usual blue, green, and red recording order. Such films cannot generally be printed with a single exposure to white light, but are designed for use in cine printers giving three separate additive exposures through red, green, and blue filters. The solutions for processing movie stocks are seldom available in prepared form, work best in the continuous processors for which they were intended and are far

from simple to compound. Also, the individual chemicals are not generally available in small quantity.

All this is written to encourage the maker of the moderately large quantities of dupes to stick to commonly available color films that can be processed in the regularly available solutions and equipment. However, anyone contemplating the use of tens of thousands of feet of film is, of course, encouraged to investigate the use of movie films. In these there are many special emulsions, such as internegatives, interpositive, and special duplicating stocks, that can have special application.

CONSISTENT COLOR QUALITY

No maker of color film guarantees that each emulsion number or batch of film will be *exactly* like the previous one or the next one in the coating machines. Most makers do try, however, to maintain a color balance variation for camera shooting films no greater than plus or minus one CC10 filter density. Duplicating films, color film designed to print slides for color negatives, and color motion picture films may show even greater variation than this at times. These films are designed for laboratories and studios that usually make extensive tests under their own conditions. Therefore, tolerances need not be held as closely as with other films. Because of this, the cost of these films is usually considerably less than that of regular camera shooting stocks. Such differences are generally unnoticed in ordinary shooting where the photographer does not have the original scene as a reference object. In duplicating, however, the difference of one CC10 density can make itself felt. To add to the problem, film can shift in color rendition after it leaves the factory, because of storage or aging. Differences in color rendition also crop up because of variations in processing conditions in different labs. Because of this, it is important for anyone contemplating the use of a large amount of film to run color rendition tests for *each new emulsion batch.*

For testing, some sort of standard original or set of originals should be kept on hand. A good idea is to have made a series of average scenes of the type that will generally be dupli-

cated. These should be carefully exposed pictures that have been properly developed—preferably by the maker of the film. Also provided should be a slide taken of a Kodak 18% gray card to which has been attached a small size set of Kodak Color Control Patches and a Kodak Gray Scale.

The gray card and color patches can prove useful to labs using a densitometer to check exposure and color balance. For those not using a densitometer the gray card and gray scale can prove useful also. The gray card can indicate at a glance in what major direction color balance may be shifting. The gray scale can indicate the degree of correctness of exposure. If too many of the lighter patches merge in density in a duplicate transparency, this would indicate overexposure. Too many of the darker patches merging, with a tendency for the lighter patches to gray over, would indicate underexposure.

To make a test of a particular new emulsion, the standard slides should be put through the duplicator using the normal filtration recommended by the maker, or using filters that gave good results with the previous emulsion. After exposing, the film should be processed and examined in relation not only to the originals, but in relation to dupes previously made. To correct for changes in color balance the new duplicates should be examined using CC filters of the opposite color of the unwanted color cast. Thus, for example, if the dupes are too greenish, examine the dupes through magenta or red CC filters. Let us assume that the dupe looks correct through a CC10R filter. This then should be added to the filter system, or the same amount of magenta subtracted. A Kodak CC Filter Dataguide, or the CC Filter Computer in the Kodak Color Dataguide, will be found useful in figuring out the proper filter combinations to use.

It should be noted that film to be tested must be stored properly prior to, between, and after exposures. Where room temperatures go up beyond 70° or 75°, the film should be removed from camera, magazines, and so on, while the test is being developed. Naturally, where film must be stored for any length of time, it is always best to place it in the refrigerator to prevent shifts in color balance.

PROCESSING

Just as important in maintaining correct color balance as the use of filters is standardization of processing. If you do not do your own, try to work with a custom lab whose work you know is consistent. Such labs will also be able to tell you of how any changes in local processing conditions may affect color rendition, so that you can take proper steps in the use of filters to make any corrections necessary.

In your own processing of films, it is important to work only with fresh solutions or those that have been properly replenished. Agitation of solutions during processing must be standardized.

A Kodak Process Thermometer or other high grade laboratory instrument should be used.

Where large amounts of film are to be handled, provision may be made for special installations having nitrogen-burst agitation, such as supplied by Oscar Fisher Co., Inc., Newburgh, N.Y.; Leedal, Inc., Chicago, Ill. 60608; Calumet Mfg. Co., Chicago, Ill. 60626; Chas. Beseler Co., East Orange, N. J.; Grafic Equipment Co., Chicago, Ill. 60640; Arkay Corp., Milwaukee, Wis.

HANDLING LONG FILM LENGTHS

Long lengths of film up to 100 feet can be processed conveniently in the Nikor Processing Machine, distributed by Honey-

Nikor processing machine handles up to 100 feet of film, is distributed by Honeywell Photographic, Denver, Colo. 80217.

Kodak Semi-Automatic Slide Mounting Machine Model 2 (right) and Kodak Automatic Film Cutter (left) team up for fast work.

well Photographic, 5501 S. Broadway, P.O. Box 1010, Littleton, Colo. 80120, or the units of the Stineman System, Los Angeles, Calif., and Kindermann, distributed by EPOI, Garden City, N. Y. 11530.

MOUNTING SLIDES

Where large quantities of slides must be mounted, special equipment as supplied by the Pako Corp., Minneapolis, Minn.; Eastman Kodak Co., Rochester, N. Y.; Seary-Michelbach Corp., Endicott, N. Y.; Byers Photo Equipment Co., Portland, Ore.; Burke & James, Inc., Chicago, Ill. 60604; and others.

Seary Slide Sealer speeds up small to medium-large quantities of slide binding.

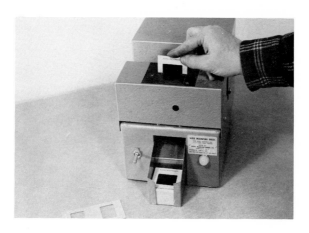

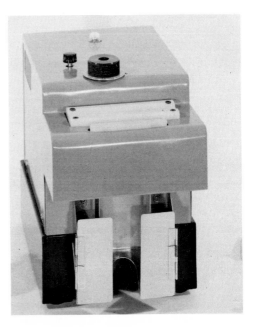

Kodak (above) and Seary (left) slide mounting
presses are quantity professional units.

Space does not permit discussing the various types of slide
mounts and methods and their advantages or disadvantages.
The subject is covered thoroughly in Amphoto's *Mounting, Pro-
jecting, and Storing Slides* by Norman Rothschild and George
B. Wright.

9

Requirements of Originals

CHOOSING FROM EXISTING SLIDES

The old adage that "you can't make a silk purse out of a sow's ear" applies in large measure to slide duplicating. Unless your original has the makings, you may have considerable difficulty in getting the results you desire.

SHARPNESS AND GRAIN

Any slide that appears sufficiently sharp when projected under average conditions may be considered sharp enough for same-size, or 1:1, duplication.

Standards are more rigid if you desire to crop out sections of a transparency for better composition, or if the dupe is to be shown on a larger than usual size screen. Before making dupes of this nature, examine your slides critically with a magnifier. The power of this magnifier should at least be equal to the number of diameters you wish to enlarge a section. Thus, for a four-diameter blowup employ a 4× magnifier.

Another consideration in cropping is grain. In duping this is often exaggerated, since the grain pattern of the original does not generally mesh with the grain in the duplicating film. This leads to a sort of mealy, amorphous "moiré." This cannot be foretold by examining the original, nor can it be seen on the

groundglass of your copying unit. Only experience will tell you just what you can expect in the way of grainy appearance with any particular film combination. Needless to say, the finer the grain in the original and the finer the grain of the duplicating film, the less trouble you'll have on this score.

For shooting originals Kodachrome II and Kodachrome-X have the finest grain and resolution. GAF 64 Color Slide runs a close third on this score. Faster films tend to be grainier. For duping, Anscochrome Duplicating Films Type 5470 and Type 6470, and Kodachrome II offer the finest grain consistent with good duping gradation.

Finally, the balance between grain and resolution are also best in transparencies that have been exposed correctly and processed normally.

COLOR QUALITY

Naturally, your choice of which color slide to duplicate will depend a lot on your own personal taste and needs. Nevertheless, there are certain things you can look for in originals which will help you get better dupes.

The easiest transparencies from which to make dupes have rich color and detail throughout, are low in contrast, and are free from objectionable color cast. It should be emphasized that although there are corrective techniques that can be employed in duping slides, there is no known simple photographic method that can be used to put detail into underexposed and blocked up or badly overexposed and washed out areas. Color casts tend to be exaggerated in duplicating, and the cast may not take on exactly the same hue in the dupe. In some cases this may be helpful, but generally the new cast is unpleasant.

CLEANLINESS

The lens of the duplicating camera is uncompromising. It sees dust, dirt, and scratches with the same uncanny accuracy as it does the beauty in your original. The spots, scratches, and mars that finally appear in the dupe cannot, unlike those in the

original, be brushed off or corrected. Motto: clean slides thoroughly and take care of them. (See *Mounting, Projecting, and Storing Slides,* by George Wright and Norman Rothschild.)

MAKING SLIDES FOR DUPLICATION

An ounce of prevention being a pound of cure, let's look at ways to make better slides to begin with.

To insure really sharp results, use a tripod wherever possible. Failing this, use the highest shutter speed consistent with depth of field requirements. Wherever possible also use medium stops, the greatest lens sharpness being at about two or three stops less than the maximum aperture. Choice of film is important too. Kodachrome II and Kodachrome-X give the finest grain and the highest resolution, with GAF 64 Color Slide, Agfachrome, Ektachrome-X, and Dynachrome 64 coming quite close.

Wherever possible, keep lighting contrast low. Outdoors use reflectors or fill-in flash to keep shadows from becoming too dark. Indoors maintain a lighting ratio of about 1:2 with a maximum of 1:4. Where control over lighting contrast is not possible or where the subject contains extremes of light and dark colors, you can keep contrast down by shooting at lower than normal indexes and processing specially (see Chapter 10, "Light, Film, Exposure, and Processing"). This results in lower contrast transparencies more suitable for duping.

DUPING FROM NON-IDEAL SLIDES

Underexposure, overexposure, and incorrect color balance can be compensated for while duping.

To render incorrectly exposed slides *as is,* give *one stop* more or less exposure for *each* estimated stop of under- or overexposure, respectively. For example, a normal copy requires $f/22$. To copy a slide underexposed *one* stop, use $f/16$. To *compensate* for incorrect exposure, open or close the diaphragm *two stops* for *each* estimated stop of under- or overexposure, respec-

tively. Thus, if a normal slide requires $f/22$, then a slide under-exposed *one* stop will require *two* extra stops, or $f/11$.

It should be noted that compensating for under- and over-exposure in duping cannot add shadow or highlight detail when these are not present in the original!

CORRECTING COLOR BALANCE

If your transparency is too blue because you used a Type A, CK, B, or F film in daylight without a filter, this can often be corrected in duping by using a salmon-colored 85, 85B, or 85C conversion filter, respectively. Conversely, if your transparency is too reddish because you used daylight film under floods or clear flash without a filter, then use of a blue conversion filter, such as the 80B or 80C, may prove helpful. For more subtle changes in color rendition, due to use of light of the wrong color temperature, use one of the 81 (yellowish) or 82 (bluish) light balancing series filters.

Where the unwanted color cast is in one of the primary colors (red, green, or blue) or in a secondary color (yellow, magenta, or cyan), one of the CC, or color compensating, filters should be used. These are available in seven densities of each color.

To check beforehand which filter to use, place your slide on a light box and view it with filters complementary to the unwanted color balance. When doing this, ignore extreme highlight or shadow areas, observing mainly the effect the filter has on the middle tones.

When the proper filter or combination of filters is found, use this when making the dupe. If you are aiming at critical color balance, also make some exposures using the next lighter and darker filter or filter combination. Don't forget to allow for the filter factor. Where two or more filters are used in combination, their filter factors should be *multiplied*.

In addition to corrective use, filters can be used to create unusual and even bizarre effects. Bluish filters may be used to emphasize coldness or accentuate fog scenes; yellowish filters to warm up outdoor scenes or make portraits taken in shade take

FILMS, FILTERS, LIGHT SOURCES FOR DUPING

	Daylight (18)	Electronic Flash (15)	Photoflood 3400K (29)	Studio Floods 3200K (31)	Enlarger Lamps 3000K (33)
Electronic Flash (15)	CC10C (R3)	None	80B+82A (B14)	80B+82C (B16)	80B+82A+82C (B18)
Daylight Type (18)	None / None	None [1] (R3)	80B [4] (B11)	80B+82A [5] (B13)	80B+82C (B15)
Negative Color (26)	85C (R8)	85 [2] (R11) [2]	82A (B2)	82C (B5)	82C+82A (B7)
Type A (3400K°) (29)	85 (R11)	N.R. / N.R.	None / None	82A (B2)	82C (B4)
Type B (3200K°) (31)	85B (R13)	85B [3] (R13) [3]	81A / R2	None / None	82A / B2
Duplicating & Slide Printing Films (33)	85+CC30G (R15+CC20G)	85B+CC30G (R18+CC20G)	81D [6] / R4 [6]	81A [6] / R2 [6]	None [6] / None [6]

Numbers in parenthesis are decamired values

Figures in bold type are most likely to give acceptable results. Figures in light face are for experimental or emergency use only. All figures are suggested only, subject to test under your own conditions, and modifiable according to taste.

Film, Filters, Light Sources for Duping (Code)

1. For warmer results try 81A for Kodak films; 81A or UV16 for Ansco films; UV16 for Agfa film.
2. Recommended for negative color films only.
3. Recommended for High Speed Ektachrome Type B only.
4. Try 78A with High Speed Ektachrome.
5. Try 78A+82A with High Speed Ektachrome.
6. Heat absorbing glass, plus UV16P filter for Ansco films or 2B filter for Kodak films should be in optical system at all times. Where it is not possible to use heat absorbing glass, substitute a CC30G (or CC30C+CC30Y) filter.

Always check any supplementary filter data packed with your color film. Also keep on alert for major changes announced by film makers.

on a sunny look. The six colors of CC filters allow wide play of your imagination. In addition to these filters, the red, green, and blue as well as deep yellow, blue-green, and magenta filters used in black-and-white work can be used in the production of interesting montages and abstract effects. (See *Filter Guide,* an Amphoto book by Cora Kennedy and Norman Rothschild, for more filter data and filter factors.)

Light-balancing and CC as well as over 100 other filters are available from Kodak in inexpensive gelatin form. Magenta, Cyan, and Yellow CC filters in acetate form are available from Kodak (CP Filters), Agfa, Spiratone, and Ansco (CC Filters).

Before closing this section on filters, it should be emphasized that there are limits to the amount of correction you can make successfully.

One concept about filters *must* be kept in mind, and that is that filters never *add* their color to the dupe but rather that some of the color from the original is being *subtracted.* Thus, using a blue filter simply subtracts red and green from the scene. Remembering this concept will keep you from trying to add color to dupes where this color is not present. An extreme example of this is a slide in which there are no greens or blues of any importance, say a scene exposed *solely* by late afternoon reddish sunset light. Use of a blue, green, or blue-green filter here in an attempt to add color would probably serve to allow little or no light to pass. Although this is an extreme example, it should be remembered at those times when you have obtained grayed-down looking dupes after trying to filter too heavily.

Still another caution about too heavy filtering is that pale, neutral highlights tend to take on the color of filters in duping. This is true also of bright colored highlights, but the effect is not often so immediately apparent. One way to keep highlights clear of this effect is to employ "highlight masking" procedures.

HANDLING DAMAGED SLIDES

Slides that have become surface scratched may be copied to show little or no damage if you apply a liquid such as Edwal No-Scratch, which has a refractive index similar to film base

and gelatin, to both surfaces. Dust, dirt, and grease may be removed with special film cleaners such as those furnished by Edwal and Kodak. *Do not use carbon tetrachloride. Its effects are toxic.*

Where scratches have destroyed one or more layers, your only alternative is to retouch the original. Where this is too small, first make an enlarged dupe, retouch or have this retouched. Then copy the dupe.

DECAMIRED FILTER SELECTOR CHART

The chart below lets you choose the proper Decamired Filter or combination of filters, without having to resort to addition or subtraction. Values are figured to the nearest 1 or ½ DM value, and are correct for average pictorial use.

	Bluish daylight, open shade, light overcast DM 14	Electronic Flash and Blue Flashbulbs DM 16	Average Sunlight 9 A.M. to 3 P.M. DM 18	Late afternoon sunlight, reddish DM 20	Clear Flashbulbs (not SM, SF or M2) DM 26	Photofloods 3400K DM 29	SM and SF Flashbulbs DM 30	3200K Studio-Type Floods DM 31
Daylight Type DM 18	R1½	R3	NONE	B1½	Bo and B1½	B6, B9 and B1½	B12	B12
Negative Color DM 26	R12	R3 and R6	R12 and R1½	R6	NONE	B3, B6 and B1½	B3	B3 and B1½
Type A and 3400K Tungsten DM 29	R12 and R3	R12	R6, R3 and R1½	R6 and R3	R3	NONE	B1½	B1½
Type B and 3200K Tungsten DM 31	R12, R3 and R1½	R12 and R3	R12	R3, R6 and R1½	R3 and R1½	R1½	B1½	NONE

To give slides protection against damage, mount them in glass. Where this is not convenient, an application of Permafilm, distributed by Edwal Scientific Products, Chicago, Ill. 60643, will clean the film and toughen the emulsion. This also suppresses minor scratches and prevents fungus growth.

An interesting and inexpensive procedure that will afford a great deal of protection to slides is Vacuumating. This process, done by the Vacuumate Corp., New York, N. Y. 10036, replaces moisture in the film with chemicals that make the emulsion waterproof, flexible, fungus resistant, and more resistant to scratches. For slides that have become somewhat dirty and scratched, Vacuumate offers an inexpensive cleaning, too.

10

Film, Light, Exposure, and Processing

As in regular color photography, the best results in duplicating are most easily obtained when light source and film are matched.

In some cases where this is not possible, the use of filters is recommended to bring about color balance. In all instances, the amount of filtration needed should be minor, as for example the use of an 81A or UV16 to balance electronic flash to daylight films, or the use of an 82 series bluish filter to balance a Type A, B, or Tungsten film for use with 211 or 212 enlarger lamps. Avoid the use of heavy conversion filters. Like all filters, these do only an approximate job of changing the color of the light. The error introduced by them is so great that it will show up in duplicating, even though it would generally not be detected in ordinary non-critical picture taking.

Films for color slide duplicating may be divided into the follow categories: camera films; special duplicating and color printing films; and motion picture films.

CAMERA FILMS

Camera films are the kind of material most readily available to the amateur photographer and will therefore be most

used by him. This is also true for the professional having to make an occasional duplicate slide.

Experience has shown that the best all-round camera–film–light-source combination for duplicating is day-light-type film plus electronic flash. Within any one brand and type of film, this combination leads to far less contrast increase and color shift than the use of a tungsten-type film plus a tungsten light source. Electronic flash also offers cool operation, and the short flash duration makes for sharper dupes, since blur from equipment vibrations is minimized.

Contrast and General Suitability

GAF 64 Color Slide is one of the best all-round duplicating camera films for general use. Its contrast is the lowest of all the camera films discussed, leading to a minimum of blocking of shadows and highlights.

Kodachrome II has similar contrast to GAF 64 Color Slide Film and is also quite well suited for general duplicating. Special advantages of this film are extremely fine grain, high resolution, and high color saturation, making it a must whenever maximum sharpness, color brilliance, and detail are to be preserved.

Dynachrome 64 has a soft gradation scale, comparable to that for GAF 64 and Kodachrome II. It is highly recommended for preserving delicate pastel colors. Grain is quite fine.

Ektachrome-X gives duplicates with somewhat increased contrast, plus greatly increased color saturation and brilliance. Interesting and startling poster-like effects can be obtained with this film. Recommended for "snapping up" weak, indifferent originals.

Fujichrome R-100 has characteristics quite similar to those of Ektachrome-X, with the added advantage of slightly increased filmspeed. It is also recommended for adding contrast to soft originals.

The contrast of *Agfachrome CT18* is somewhat higher than that of Anscochrome or Kodachrome II. It will be found

useful for duplicating wherever a somewhat heightened contrast is wanted in the duplicate.

Kodachrome-X is too contrasty for general duping. However, startling effects may be had by making a dupe, duping this on Kodachrome-X, and repeating the performance.

Ektachrome Photomicrography Film, Type 50-456, has extremely high contrast, and resolution higher than Kodachrome II. With a filmspeed of ASA 16, it will be found useful for creative effects in the same manner as Kodachrome-X. It is sold in 36-exposure cartridges and 100-foot rolls.

Type A and B Color Films

The remarks regarding relative contrast and color rendition of daylight-type color films apply in general as well to Type A and B varieties of the same brand.

The use of these films presents a number of problems not present in use of daylight film plus electronic flash. One of these is variations in color quality of tungsten lamps with changes in voltage and age. This is covered in the discussion of light sources. Another problem is heat. This latter is of little consequence when the light source can be located outside the duplicating system, as is the case with duplicators having their own slide holders and provision for diffusing glass. It is also of less consequence when using the lamphouse of an enlarger as a light source (see Chapter 6). But whenever the lamp is to be built into some sort of light box, overheating of slides, filters, and equipment becomes a serious problem.

Still another problem is contrast, which has a tendency to mount with the use of A and B films and a tungsten light.

High Speed Films

High speed color films such as GAF 200 or 500 Color Slide and High Speed Ektachrome may be used for duplicating but their use should be restricted to those situations where light levels in duplicating equipment are low and exposures must be

kept short, or where extreme magnifications lead to lengthy exposures. A disadvantage of these films is somewhat higher graininess.

Negative Color Films

It has been proposed that slides could be copied on negative camera color film, such as Kodacolor or Agfacolor, and the resultant negatives be used to produce either color prints or color transparencies. Unfortunately, this procedure generally leads to excessive contrast in both prints and finished dupe slides. However, with low-contrast originals some success is possible. The least trouble from high contrast will be experienced by using electronic flash plus an 85 or Type A filter, or Ektacolor S and no filter.

Special internegative films, from which excellent color prints or slides can be made, are available from Kodak. However, these films are available only in rolls of 100 feet or longer and require special processing, thus making them generally unsuitable for amateur use.

Kodak Ektacolor Internegative Sheet Film

This material is designed for making color negatives from color transparencies and is also useful for copying from colored flat copy, such as color prints, color art work, and similar material.

Special layers in Ektacolor Internegative Sheet film provide highlight and contrast correction masking as well as color correction. *It is not possible to use this film successfully without a good working knowledge of the use of a densitometer.*

Information about this and other internegative color films may be obtained by writing the Sales Service Dept. of the Eastman Kodak Co., Rochester, N. Y. 14650. When writing, state the *exact* use to which you will be putting the materials.

Color Rendition

So far we've discussed only contrast and resolution. But each color film has its own peculiar color rendition. No hard and fast recommendations can be made as to which of these renditions is best since personal tastes differ widely. The following information is therefore offered in order to help you make a choice. Anscochrome tends toward magenta blues. Greens and yellows are rendered with excellent fidelity and differentiation. Reds are brilliant with a tendency toward magenta rather than orange-red. Kodachrome and Ektachrome tend to shift yellows towards orange. Reds too tend towards the warm end of the spectrum. Greens are not rendered too well, tending to slate color, especially on slight underexposure. Blues tend toward cyan. Kodachrome II and Ektachrome E3 give much better all-around rendition than Kodachrome or Ektachrome. Greens are better differentiated, reds and yellows are much less orange, and skies are rendered quite naturally.

You can take advantage of the inherent color characteristics of each color film to make color corrections during duplicating. In a slide having reds too magenta and a purplish sky, for example, correction can often be made by copying on Ektachrome, which shifts the red toward orange and the blue to bluegreen (cyan). On the other hand, a slide in which yellows are too orange and blues too cyan can sometimes be corrected by copying on Anscochrome, which shifts yellow toward green and blue toward violet.

It should be emphasized again in discussing renditions of these various films that there are no hard and fast rules. Some variation in color rendition may be expected from batch to batch. For critical work the procedures outlined in the chapter on quantity duplicating should be followed.

DUPLICATING FILMS

Special duplicating color films include Anscochrome Duplicating Film Type 5470 available at 35mm film in 100-foot rolls

and 36-exposure cartridges, Anscochrome Duplicating Film Type 6470 in standard sheet film sizes, and 35mm Ektachrome Reversal Print Film Type 5038 in 100-foot bulk rolls. The cost of these films is considerably lower than that of camera films, being about one-third in the case of 35mm and one-half in the case of sheet film.

Duplicating films from bulk rolls may be successfully loaded into cartridges for use in duplicating with ordinary cameras, by employing a bulk film loader such as the Watson 66 made by Burke & James, Inc., Chicago, Ill. 60604. This accommodates 100 feet of film. It is not practicable for the average photographer to bulk load from 100-foot film rolls.

The special characteristics of these films include fine grain, low contrast specially suited for duping, and good characteristic curve conformity insuring accurate rendition of the various colors in the original. (Curve conformity simply means that all three sensitive color film layers behave similarly in regard to exposure and contrast. Lack of similarity generally leads to color distortions.)

The color balance of the light source for GAF films is 2900 to 3000 K (211 or 212 enlarger lamp). Ektachrome Type 5038 is balanced for 3200 K. In the case of Type 5470 and 6470 there should always be a heat-absorbing glass plus an Ansco UV16P filter in the light beam. Ektachrome 5038 requires a heat-absorbing glass plus a Wratten 2B or CP2B filter at all times.

Anscochrome Type 5470 and 6470 may be processed in the same solutions and for the same times recommended for Anscochrome camera shooting films.

Ektachrome Reversal Print Film is processed in the same E-4 solutions as Ektachrome and High Speed Ektachrome, and for the same time.

Color transparencies may be made from Kodacolor and Ektacolor negatives by employing 35mm Ektacolor Slide Film and sheet Ektacolor Print films. Processing of these films is in C-22 solution. The 35mm film is available in 100-foot and longer rolls.

Agfacolor negatives may be printed on Agfacolor Positive S. This is available in 35mm rolls of 30 feet or longer, and as sheet film.

MOTION PICTURE FILMS

Both Kodak and GAF supply a great variety of color motion picture films, some of which are quite suitable for making duplicates and slides in quantity. Most of these films are available in lengths of 100 feet or more and include reversal, negative, positive print, internegative, and interpositive types.

Such films are intended strictly for professional use by those possessing the necessary exposing and processing equipment. In general, consistent results cannot be obtained if these films are processed in small tanks. Also some films, such as Eastman Color Negative, have a black remjet backing, which requires special equipment for removal.

Another problem with these films is that color balance is not kept to the same tolerances as with miniature camera shooting films. This results in lower film costs, and since studios using a lot of film make their own filter tests for each batch used, variations in basic color rendition present no difficulty to them.

Amateurs will do well to keep away from these films and others sometimes offered for sale by certain surplus film organizations.

LIGHT SOURCES

Many light sources have been suggested as being suitable for slide duplicating. These include daylight, electronic flash, tungsten lamps including 3400 and 3200 K floods, enlarger lamps, and fluorescent tubes. Their actual suitability and some problems in using each will be discussed below.

Daylight

It would seem that daylight and a daylight color film are a natural combination. In ordinary pictorial photography this is

the case. In slide duping, however, daylight is too variable both in color quality and in intensity to be considered suitable for anything but occasional use by amateurs. Daylight varies from strongly reddish very early or late in the day to very bluish in the shade or on cloudy days. If daylight is to be used, as recommended by the makers of some small slide copiers (see Chapter 4), point the unit at the horizon so that it receives sunlight. Do not point the unit directly at the sun, as doing this will pick up too much skylight, giving your duplicates a bluish cast. Work at times from about 2½ hours after sunrise to about 2½ hours before sunset. A skylight filter is recommended.

An ordinary color temperature meter cannot be used successfully for the measurement of the color quality of daylight.

Electronic Flash

This is probably the most popular source of illumination for duping by both amateurs and professionals. Electronic flash is cool; its short duration minimizes blur from equipment vibrations; its color quality and quantity of illumination are constant from flash to flash. The soft quality of the light makes for a minimum of contrast increase in the dupes. Most electronic flash units emit light that is bluer than that for which daylight films are balanced, requiring an 81A filter for Kodak, Dynachrome, and Fuji films, and a UV16 for GAF and Agfachrome materials. For cooler or warmer results the next stronger or weaker in the 81 and UV series, respectively, should be tried. Also consult the film maker's supplementary filtration instructions in the data sheets packed with some films.

For most consistent results with electronic flash units AC should be used rather than a battery power supply. Adequate time should be given for the unit to recycle after each flash to guarantee uniformity of exposure (approximately twice the time it takes for the neon indicator lamp to glow).

Tungsten Light Sources

The color quality of these light sources is affected by changes in line voltage and by the use-age of the lamp.

To assure constant color quality of the light some sort of voltage control should be installed, especially when extensive duping is to be undertaken. Sources of these include Industrial Timer Corp., Newark, N. J.; General Radio Co., Ridgefield, N. J.; A & F Photo Equipment Co., Los Angeles, Calif.; Sola Electric Co., Elk Grove, Ill.; and Chas. Beseler Co., East Orange, N. J.

Some record should be kept of the number of hours each lamp is in use. In general, lamps should be used for duping for about three-quarters of their rated life. At the beginning of the lamp's life color quality will be a bit on the cold side, while near the end of the lamp's rated life the light will become more reddish. Of all the light sources named 211 and 212 lamps suffer least from age color deterioration, photoflood 3400 K lamps most. Any lamp that shows decided blackening should not be used for critical color work.

For extremely critical work the color quality of a tungsten lamp can be measured with a color temperature meter. Sources of these include Minolta and Kling Photo Corp. (Gossen), New York, N. Y.; Karl Heitz Inc. (Rebikoff), New York, N. Y.; Photo Research Corp. (Spectra), Hollywood, Ca. The color temperature of a tungsten lamp can be changed by means of a rheostat voltage control. Raising the voltage leads to bluer light, lowering it leads to yellower light. It is also possible to change the color temperature using Kodak Light Balancing filters, Ednalite Color Toning Filters, or Decamired filters. The former method is preferable whenever extremely precise control is desired.

As already mentioned in the discussion of Type A and B films, tungsten light sources present a heat problem. Any light box should be constructed with adequate ventilation, and if possible a blower system installed. An excessively hot setup shortens lamp life as well as the life of slides, filters, and so on. An

ideal tungsten light source is the lamphouse of a good enlarger (see Chapter 6).

Quartz-Halogen 3200 and 3400 K

Essentially a quartz-halogen lamp is a tungsten lamp with a small quantity of halogen gas inside a lamp envelope made of quartz. The advantages of this sort of light source are relatively constant color temperature throughout the entire life of the lamp and efficient and constant quantity of light output.

The constant color temperature and quantity of light should make quartz-halogen an ideal light source for duplicating with Type A or B as well as special duping and slide-making films. However, quartz-halogen lamps are not suitable for on-off operation like ordinary tungsten lamps. Turning a quartz-halogen lamp on and off frequently shortens its life drastically, at the same time blackening the lamp rapidly and diminishing the light output. Therefore, such lamps are suitable for use only in well-ventilated equipment where the lamp can burn constantly, the exposure being made with a shutter or other device. For constant color quality and output a quartz-halogen, like other tungsten lamps, should be provided with some sort of voltage control for critical work.

Fluorescent Lamps

Unfortunately, the color quality of fluorescents is not too well suited for duping. The reason is a discontinuous spectrum, resulting in some colors being very weak or completely missing and other colors being emitted excessively. No amount of filtration will cure this condition to the complete satisfaction of the critical worker.

EXPOSURE

It would be nice for me to be able to give specific exposure recommendations for each and every slide duplication situation, but with individual duping setups varying as widely as they do this is an impossibility. The table of basic exposure recommen-

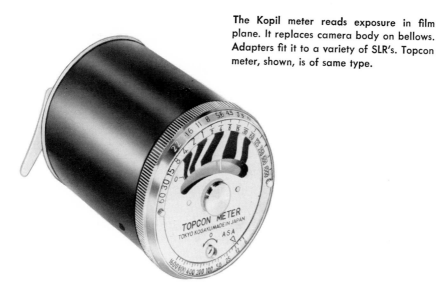

The Kopil meter reads exposure in film plane. It replaces camera body on bellows. Adapters fit it to a variety of SLR's. Topcon meter, shown, is of same type.

dations should be used therefore only as a guide or starting point for your own setup. Also consult exposure tables and suggestions that sometimes accompany the duplication equipment of your choice.

MAKING TESTS ON BLACK-AND-WHITE FILM

Exposure tests with color film can become a costly pastime. Preliminary tests should therefore be made using black-and-white film of a speed similar to the color film to be used for duping. This should be processed in the formulas and for the times

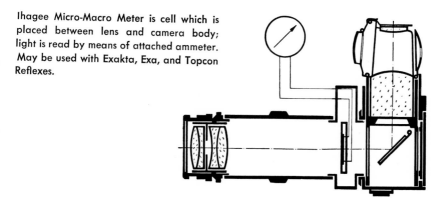

Ihagee Micro-Macro Meter is cell which is placed between lens and camera body; light is read by means of attached ammeter. May be used with Exakta, Exa, and Topcon Reflexes.

specified by the film manufacturer. Once an approximate exposure time has been found, final tests can be made on color film.

EXPOSURE METERS

The cell of most common selenium photoelectric meters is too large to be used for selective readings in slide duplication work. However, once the exposure for an average transparency has been found by test, an ordinary meter may be used to make *comparative* readings of lighter and darker slides. For this a small light box should be constructed having an opal glass window masked down to transparency size. Some provision should be made so that the cell of the meter always comes to rest centered over the transparency.

Kopil Meter and Ihagee Macro-Micro Photometer

The Kopil Meter consists essentially of a tube that is the length of a reflex body. At one end is a photocell whose opening is the same size as that of the film. The other end has a female lensmount. In use, the subject is first focused with the camera in place on an extension bellows. The meter is then substituted for the camera body, and exposure readings are made. These, of course, will be accurate no matter what the extension used, since the light coming directly from the lens is being measured.

The Ihagee device is in the form of a flat plate placed between lens and camera body. Readings are made with a hypersensitive microammeter, which is purchased as an accessory.

Through-the-Lens Metering with SLRs

In cameras of this type the light coming from the lens is read by built-in CdS cells. This can be a decided convenience for those of us who have to make a considerable quantity of dupes. Since the reading reflects actual picture-taking conditions, there is no need to compensate for extensions.

At first thought, it might be assumed that filter factors are automatically compensated. Since the color sensitivities of CdS

cells and of film do not coincide, it is best to follow recommend-ed filter factors, setting these manually.

It should be emphasized that ordinary meters and the above devices deliver only a fair basis for exposure, since they ignore contrast of the original and are fooled by slides not hav-ing an even density distribution. For example, in a subject with a small object surrounded by a large mass of darkness, the me-ter will take an overall reading indicating a totally dark slide, and the object will be overexposed. Placing this same object on a light background will give a high reading, and the object will be underexposed.

SELECTIVE EXPOSURE METERS AND DENSITOMETERS

Sources of ultra-sensitive and selective exposure meters and densitometers include Eastman Kodak Co., Rochester, N. Y. (Kodak Color Densitometer Model I and RT); Karl Heitz, Inc., New York, N. Y. 10017 (Volomat); and Lester C. Hehn Engi-neering, Port Washington, N. Y. (Printor). These three named are in the relatively low-priced field. Sources that follow are more expensive precision devices for advanced amateur or pro-fessional work: GAF, Binghamton, N. Y.; Burke & James, Inc., Chicago, Ill. 60604; Electro-Physics Co., New York, N. Y. 10007 (Printometer); Walter Voss, Inc., New York, N. Y. 10032; Zoomar, Inc., Glen Cove, N. Y. (S. E. I. Photometer); Fotomatic Corp., Indianapolis, Ind. (Elwood Fotometers); Ex-potrol, Spiratone, Inc., New York, N. Y.; S.O.S. Cinema Supply Corp., New York, N. Y. 10019; and W. M. Welch Mfg. Co., Chi-cago, Ill. 60610 (Densichron). Inexpensive enlarging meters that read fairly small areas are supplied by Ideax Corp., New York, N. Y. 10011 (Photo Genie) and Kinnard Co., Milwaukee, Wis. (Spot-O-Matic CdS). When writing to these companies ex-plain your problem, indicating the kind and quantity of work you wish to do, and whether readings are to be taken directly from the transparency or from an enlarger baseboard.

At this writing an increasing number of cadmium sulfide cell meters are making their appearance. These promise greater sensitivity, in some cases coupled with narrow selective viewing angles. Included in this group are the Gossen Luna Pro, Minolta Autometer Professional, Honeywell 1°/21°, Sekonic L-2802, and the Elwood Fotomatics, as well as the Spot-O-Matic CdS enlarging meter. (See *Guide to Perfect Exposure*, by George Wright and Cora Wright Kennedy, Amphoto, 1967, for a description of how these work.)

PROCESSING

The quality of your color slide duplicates can be strongly influenced by the kind of processing they get. The results from different labs can vary widely in color. Our first and strongest advice on this score therefore is find a good processor and stick with him if you want consistent results. *Avoid bargain-basement cut-price finishers like a plague!*

For special effects, processing of some color films can be altered from the normal.

By using longer than normal exposures and holding back or giving shorter developing times, you can make dupes with reduced contrast. Increased contrast can be obtained by giving less than normal exposure and extending development times. The exact effect you want will have to be determined by actual test.

NOTE: Before experimenting with altered developing times, first make some dupes of a problem original using normal processing. This will then serve as a reference point, to let you know just where your experimentation is taking you.

Figures in Tables A, B, and D apply to setups in which a groundglass is used to diffuse the light. Give about twice the exposure shown when using an opal glass.

Sandwiching two identical 35mm transparencies of flowers leads to a wild, woolly abstraction. Here, two identical slides were obtained by making two copies of an original. Slides or copies for superimposition should be on the light or slightly overexposed side. Upper picture is a straight copy of sandwich, one below copied through a Kodak Wratten 33 magenta filter. For sharpest focus, slide sandwich should be mounted between slide glasses.

Laying textured glass atop a mounted slide can lead to interesting transformations. In the upper picture a straight copy was made of a shot of Mexican balloons. The one below was copied through St. Gobain *Diffusex* glass. Large illustration at right was made by crossing fluted *Ribbed* and *Skytex* glasses atop slide. Small stops should be used to get all sharp. Textured glasses are available at local glaziers.

Almost limitless alteration of color balance may be achieved by use of filters. Thus, the skillful slide copier can create special effects and moods. The image at the upper left is a straight, unadulterated view of a sign painted on the wall of a puppet show in Mexico. This was then copied through a deep green No. 58 filter. Picture at right was made using a Kodak Wratten 33 magenta filter.

Copying and recopying can lead to strong, poster-like results. Upper left is an original showing a full range of tones. To the left of this is a high-contrast version made by copying and then copying the copy. Regular film, not duplicating film, is used to get extra contrast. In version at left below, two exposures from the first copy were made on a single piece of film. Before the second exposure was made, the slide was removed from the slide holder and reversed from left to right.

More than one operation may be accomplished when copying a slide. Original above has been slightly underexposed, making colors dark and dull. Result below, which is brighter and somewhat contrastier, was obtained by giving extra exposure during duping. Final experiment resulted in large illustration at right. Here the original was copied through a Rosco Deep Lavender stage gelatin.

If your telephoto lens isn't long enough or you can't get up close enough, you can resort to cropping out the desired area, during slide copying. Enough extension must be available for making larger than life size images. The original, above left, was made at a nightclub in Tokyo. Version to the right of this is a two-diameter blowup. Final version directly to the right was copied through a Kodak No. 35 deep magenta filter. Cropping may also be used to correct poor framing.

TABLE A

For 3200 K, 500-watt lamp in reflector—Lamp 11 in. from slide—Ratio of reproduction 1:1.

Film	Exposure
H. S. Ektachrome, Type B	1/125 at f/18
GAF Color Slide, T/100	1/60 at f/22
Kodachrome II, Type A	1/30 at f/18*

*With 82A filter.

TABLE B

For small electronic flash unit having a guide number of 45 for Kodachrome II. Ratio of reproduction 1:1 and an aperture of f/16.

Daylight-type film	Lamp distance from slide
GAF Color Slide 500	24 inches
High Speed Ektachrome	16 inches
GAF Color Slide 200	16 inches
Fujichrome R-100	11 inches
Ektachrome-X	9 inches
Kodachrome-X	9 inches
Dynachrome 64	9 inches
Agfachrome CT18	9 inches
Kodachrome II	5½ inches
Kodak SO 456	4 inches

TABLE C

No. 212 enlarger lamp in enlarger lamphouse (condenser)
Anscochrome Duplicating Film Type 5470 or 6470
Magnification ratio 1:1
One second at f/22

For diffusion tungsten enlargers try 2X to 4X the indicated exposure.

Enlarger should have Ansco Heat-Absorbing Glass and a UV16P filter in the optical system.

The above times apply *both* when using the enlarger lens to project directly onto the material on the easel or in a camera; or when a camera is pointed at the lamphouse using the camera lens and an extension. (See Chapter 6, "Enlargers and Projectors for Duping.")

For Kodak Duplicating Films, try 2X to 4X the indicated exposures.

TABLE D

No. 212 Enlarger lamp in 12-in. polished reflector
Lamp distance from slide 12 inches
Anscochrome Duplicating Film Type 547
One second at $f/16$

Optical system should have an Ansco UV16P filter and a heat-absorbing glass.

Where it is not possible to include a heat-absorbing glass, substitute a CC30G filter or a combination of a CC30Y+CC30C.

For Kodak Duplicating Films, try 2X to 4X the indicated exposures.

TABLE E

Exposure Increase Factors in Comparison with
1:1 Magnification Ratio

Image smaller than life size (reduction)	
1:10	0.3X
1:5	0.36X
1:2	0.55X
Same size	
1:1	1X
Image larger than life size (magnification)	
1.5:1	1.6X
2:1	2.25X
3:1	4X
4:1	6.25X
5:1	9X
6:1	12.25X
7:1	17.25X
8:1	20.25X
9:1	25X
10:1	30.25X

VARIOUS OTHER PROCESSES

In the main, this book deals with the use of color negative and reversal films in the production of slide duplicates, filmstrips, and titles. However, there are a great number of other processes, useful for this kind of work, some of which are not normally encountered by the average photographer. These are

presented here in the hope that not only will they prove useful for some special job, but that they will serve as a reminder of the vastness of the family of light image forming processes, and as a stimulus toward experimentation and creative expression.

The Polaroid Process

Polaroid material represents a quick method of obtaining high-quality black-and-white prints or slides that can have wide use in the audio-visual field.

Two Polaroid print sizes are available in rollfilm. Most cameras make 3¼″ × 4¼″ images, while the Highlander cameras, the J33, and the Swinger make 2½″ × 3¼″ shots. In sheet form there is also Polaroid 4″ × 5″ film. Polaroid prints may be used in preparing a lecture using an opaque projector, such as those offered by Chas. Beseler Co., East Orange, N. J.; American Optical Co., Southbridge, Mass.; Bausch & Lomb, Inc., Rochester, N. Y.; and Edmund Scientific Co., Barrington, N. J.

For general continuous tone work Polaroid Film Types 37 and 47 (E.I. 3200), and 32 (E.I. 400) and 42 (E.I. 200), will prove useful. Types 37 and 32 fit the Polaroid Highlander and similar cameras making 2½″ × 3¼″ pictures. Type 20 makes 2½″ × 3¼″ prints and is used with the Swinger. All other Polaroid rollfilms make a 3¼″ × 4¼″ paper print.

Owners of 4″ × 5″ press or view cameras, or other cameras equipped with a Graphic, Graflok, or Linhof back to use 4″ × 5″ sheet film, can utilize Polaroid Land 4″ × 5″ film packets. A special Polaroid Land filmholder is necessary.

Five different sensitive Polaroid sheet materials are offered, Type 52 (E.I. 200); Type 57 (E.I. 3200); Type 51 high contrast for line and copy work; Type 58 color film (E.I. 75); and Type 55 P/N (E.I. 50). The last named type, P/N, is unique in that it not only produces a paper print, but also a fine-

grain high-resolution negative. This negative is suitable for production of prints or enlargements by any conventional method. It may also be used for the production of black-and-white slides on materials such as sheet Kodak Fine Grain Positive, or on commercial films of various makes. Such positives are large enough for use in an overhead projector.

For making high contrast copies of line subject matter, such as type and diagrams, there is Polaroid Polascope rollfilm Type 410 with an exposure index of 10,000! Although originally intended for recording oscilloscope and other cathode ray tube traces, many other uses will be found for this phenomenal material. Type 51 high contrast material, previously mentioned, is supplied in the form of Polaroid Land 4 × 5 film packets.

Polaroid Land projection films are made in two general types, one producing high contrast line transparencies, the other continuous tone slides. Type 146-L with an exposure index of 200 makes eight 3¼″ × 4¼″ line transparencies per roll.

Mounted in the handy Polaroid plastic slide mount, these are then ready for showing in any standard 3¼″ × 4″ lantern slide projector, or the Polaroid projector. Mounted or unmounted they are also extremely well suited for use in an overhead machine.

Type 46-L makes eight 3¼″ × 4″ continuous tone transparencies per roll.

The Polaroid MP-3 Multi-Purpose Industrial View Land camera is a valuable addition to any establishment specializing in audio-visual work. It is ideal for slide making, copying, small object photography, photomicrography, macrophotography, gross specimen work, wall chart copying, and many other types of work. The four reflector floods assure even lighting.

A special advantage is to be had in the use of Polaroid films, since results can be seen almost immediately, either in black-and-white or color. Materials that are supplied by Polaroid include those making continuous tone black-and-white prints; high contrast black-and-white prints; continuous tone

and high contrast black-and-white transparencies and color prints. There are also special infrared and oscilloscope recording materials and an X-ray diffraction cassette for scientific use.

The originals made on the Polaroid MP-3 cameras can be of high image quality and are highly suitable as originals for incorporation into slide lectures, slide films, or titles.

The Polaroid MP-3 camera accepts the Polaroid Land Roll-film Back and Polaroid Land pack and the Polaroid 4″ × 5″ Filmholder #500 for use with Polaroid Land 4″ × 5″ film packets. It will also accept standard 4″ × 5″ cut film holders, and a variety of holders for 120, 220, 70mm, and 35mm film in adapters supplied by Graflex, Polaroid, Beattie Coleman, Linhof, and others.

Focusing is on a reflex ground glass that is marked off for 24 × 36mm, 3¼″ × 4¼″, Land Transparency, and 4″ × 5″ formats.

A wide range of accessories for halftone, scientific, and other work is available from Polaroid. They are also cooperative in helping you locate special equipment for use in connection with this and other Polaroid units.

Polacolor Film

This material presents a quick method of obtaining color prints from slides in a hurry. These could be suitable for opaque projectors.

You can also shoot Polacolor originals and have slides made from these by the Polaroid Corp.

Diazo Processes

Diazo materials are capable of producing images in a variety of colors such as red (magenta), green, blue (cyan), yellow, black, and brown. Both paper and film base materials are avail-

able from a number of manufacturers. Paper base diazos are useful for lecturers using an opaque projector, while diazo prints on transparent or translucent base make excellent slides for use in an overhead machine.

In the diazo process the action of light (ultraviolet, chiefly) destroys compounds capable of forming dyes in their unexposed state. Thus, if a negative is placed upon an ordinary diazo-coated material and an exposure is made, the areas under the dark, or highlight parts of the negative, having received little or no light, would come out dark in the print. The areas under light or shadow areas would come out light. The result, therefore, is a negative from a negative. In order to produce a positive image, an intermediate positive would first have to be made, using such materials as Kodak Fine Grain Positive Film, Commercial Film, or Kodak Gravure Copy Film. Of course, if you already have a positive, such as that made by Polaroid Projection film, you can then make another positive directly in any color using diazo. There are also a limited number of diazo materials capable of producing a positive from a negative.

The sensitivity of diazo materials is very low, compared with silver compound photographic materials. Therefore, exposure is by contact only. For this purpose strong daylight, special high ultraviolet content fluorescent tubes, mercury sun lamps, or a special diazo printing machine may be used.

Most diazo materials are contrasty and suitable only for line subject matter such as plans and engineering drawings. However, there are certain types with an extended gradation scale, making them suitable for continuous tone subjects. The tonal scale, however, is rather limited compared with regular photographic, silver sensitized material.

Development is by ammonia vapor, or a special bath, depending on whether "dry" or "wet" process diazo material is used. Generally speaking, the small-scale user will be best off using dry materials. With these it is possible to use a very dilute ammonia solution, such as *clear* household ammonia. This

should be used in a well-ventilated room. Where quite a quantity of work is to be done, investment in a diazo printer, which exposes the material and passes it through the developer, may be a wise investment.

While many firms make diazo materials and equipment, the following concerns are listed because they offer diazo materials in quantities small enough for experimentation and occasional work. They are the Ozalid Div., General Aniline & Film Corp., Johnson City, N. Y., and the Technifax Corp., Holyoke, Mass. Diazo products are not generally available at ordinary photo dealers. Both concerns will direct you to a source of supply.

Color Toners

Changing the color of a black-and-white image, such as one made on black-and-white positive film, to another color by chemical means is called *toning*.

TONER CHART

Bleach and redevelop	Type	Color
Kodak Sepia Toner	Sulfide	Sepia, brown
FR Develochrome*	Dye-coupling	Red, green, blue, yellow, sepia
Direct Toners		
Kodak Blue Toner	Gold	Blue, blue-gray**
Kodak Brown Toner	Sulfide	Sepia, warm brown
Kodak Rapid Selenium	Selenium	Reddish to cold brown
Kodak Polytoner	Selenium-sulfide	Cold brown to sepia
Ansco Direct Sepia	Sulfide	Sepia, warm brown
Ansco Flemish Toner	Selenium	Reddish to cold brown
Edwal Color Toners	Dye-mordant	Red, green, blue, yellow, sepia

*May also be used to develop a colored image directly without bleaching. See instruction sheet. Toners may also be mixed to produce intermediate colors. Information on Develochrome may be obtained from the FR Corp., Bronx, N. Y.; on Edwal Color Toners from Edwal Scientific Products Corp., Chicago, Ill. 60628.
**Tones prints that have previously been toned in a sepia toner to chalk red.

Toning will be found useful whenever a purely black-and-white image is either lacking in interest, when it is desired to simulate the color of the subject in monochrome, or where only a black-and-white slide is available and it must be shown along with a series of color transparencies. You'll also find toners valuable in creating colored titles and for purely experimental work.

The range of colors available in commercially prepared toning solutions is fairly wide. (The exact tone obtained with each toner depends on the way the original silver image was developed. Space in a book of this type does not permit a full discussion of this. However, books such as the *Focal Encyclopedia of Photography, The British Journal Almanac, Amphoto Lab Handbook, Processing and Formulas,* and *Photography, Its Materials and Processes* are good reading matter on this subject. These books are available at your dealer or at Amphoto, Garden City, N. Y. 11350. Colors obtainable with toners include sepia, reddish brown, yellow, magenta, blue-green, and green.

In general, toners may be divided into two classes. Those which require bleaching the silver image, after which it is redeveloped to the desired color, and toners in which direct immersion of the film leads to a color change.

3M COLOR KEY

This may also be used to make overhead projection slides in various colors from line Polaroid transparencies or line negatives and positives made by other processes.

It requires no darkroom, but must be shielded from ultraviolet light, to which it is most sensitive. Exposure is by carbon arcs, mercury vapor, daylight, xenon arcs, or other light sources rich in ultraviolet light. Printing is by contact.

Development is by wiping on volatile chemicals. This removes the image in unexposed areas in the negative action Color Key and vice versa in the positive acting material.

Although intended for line work or proofing halftone screened negatives, Color Key can be used experimentally for poster-like effects from continuous tone originals. A variety of colors are supplied, including yellow, magenta, cyan, red, green, blue, and black.

More data may be obtained from 3M, Printing Products Div., St. Paul, Minn.

11

Titling

A series of well-thought-out titles serve to tie a slide lecture together. In cases where a lecture must be given a number of times, as with professional talks, photographic titles will assure that the correct statement will be made about each slide each time. This may not necessarily be the case if the lecturer has to depend on memory or read from a prepared script.

Making titles is also a challenge to your artistic ingenuity. A cleverly and tastefully made series can lend "class" and zest to a slide show.

READY-MADE TITLES

An effortless way to add titles to your slide show is to buy ready-made ones from various concerns. The only danger in doing this is that your show will then not have the individuality that comes from making your own. Some concerns supplying ready-made slides are Atkins Travel Slides, Inc., San Francisco, Calif.; Karl Heitz, Inc., New York, N. Y. 10017; Mestons Travels, Inc., El Paso, Texas; Thoro Products, Reseda, Calif.; and Universal Color Slides, New York, N. Y. 10028. Also consult

the ads appearing in the photo magazines *Modern Photography* and *Popular Photography*.

Graflex Title Slide

Title slides can be made on the spot in an emergency, using either of these two devices.

The Graflex Title Slide consists of a 2″ × 2″ slide mount with a 35mm opening. In the opening there is a piece of matte-surfaced glass on which you can write your message using pencil, pen, or crayon. If desired, you can erase the message and start over again, but this is a messy procedure and is hardly worth the saving of the few cents that the Graflex slide costs.

In the 35mm Title Slide, the message is also written on a matte surface with pen, pencil, or crayon. The surface in this case is acetate rather than glass. Title slides come in white, yellow, red, green, or blue acetate.

Data on Graflex Title Slides may be obtained from Graflex, Inc., Rochester, N. Y., and on Title Slide from Title Slide Co., Kirtland, Ohio.

The Graflex Title Slide consists of a 2″ x 2″ slide mount with an opening for a 35mm slide.

SHOOTING TITLES IN THE FIELD

On-the-spot opportunities to make title slides out of ordinary subject matter should not be overlooked. On a trip, signposts, billboards advertising your destination, and familiar landmarks—all may be turned into title slides. Other suggestions include picture postcards, decorative restaurant menus, and road maps on which have been drawn the route of the trip. If the slide lecture you plan is primarily a family affair, it's a good idea to include some loved ones in an occasional title slide.

Some suggestions for titles for a commercial slide show include shots of letterheads, cartons containing the product to be described in the lecture, closeups of labels, or names engraved on the product. Shots of plant interiors and exteriors are often used, combined with superimposed lettering as opening slides.

LETTERING SETS

In some articles it has been suggested that titles can be typewritten and copied for projection. The results from this sort of procedure are at best only fair, because at large-screen magnifications the type imperfections and uneven spacing caused by the average manual typewriter show up. Better results are to be obtained with a typewriter having a carbon ribbon, or a high grade manual or electric machine that is in perfect working order. For finest results a machine such as the Varityper or the new IBM Selectric is recommended.

Better yet are the letter sets used for motion picture titling. These come in several styles, and your choice will largely be dictated by which you find most convenient to use, and if the type supplied pleases you. You'll probably find it easiest to make up straight lines with the kind of letter sets in which the letters are placed into horizontal grooves. Such sets, however, do not permit much latitude in the placement of letters at odd angles for special effect. More versatile are those in which the letters fasten to the background via pins, or are held in place by adhe-

Picture postcards bought on a trip may be copied to make interesting slide titles. If slide lecture is to be used commercially, get permission of copyright owner to use them.

sion. A ruler should be used to line the letters up when straight lines are wanted. The makers of titling sets supply these with both white and colored letters. At first glance it may seem advisable to buy the latter for color but this is not necessarily so. In actuality a white letter may be made to assume any color by the use of colored gelatins over lights, or colored filters over the camera lens. Where this is not convenient colored title letters are the answer. They are also the answer where letters and background must be of different colors in a simple setup.

Two-color and multiple-color effects are also possible when the letters are placed on a pane of glass and illuminated with light of one color. A plain white background placed some distance behind the glass is then illuminated separately with light of a different color.

Letter sets in plastic or wood may be used for titling and give a three-dimensional effect.

Some other titling ideas are to place adhesive letters on plastic or other cylinders to get curved letter effects, and to tilt the copy board at an angle to the lens to create the impression of gradually receding letters. Often pictures and maps make good backgrounds on which to place title letters.

LIGHTING AND EXPOSURE

For most ordinary work, even, flat light is provided by two lamps of equal size and strength placed at 45° angles and the same distance from the copy board.

More interesting effects are obtained with the lights placed so that raised lettering throws shadows on the background. To get a shadow to go into any particular direction, remember that the light then must be coming from the opposite direction. In other words, if you want a shadow to fall to the right, move your light to the left, and vice versa. Interesting two-color effects may be had by using general illumination of one color, and angle illumination of another. This will give letters with shadows that have a color different from the rest of the scene.

Color may be imparted to the lights using stage gelatins such as those supplied by Rosco Laboratories, Harrison, N. Y., S.O.S. Cinema Supply Corp., New York, N. Y. 10019, and Edmund Scientific Co.

Exposure is best measured using an incident light meter or taking reflected light readings from the gray side of a Kodak Neutral Test Card.

For the most consistent work the color film and light combinations recommended in Chapter 10, "Film, Light, Exposure, and Processing," should be used as a base of operations. Where colored gels are used over the lights, exposure readings should be made with these in position. When colored filters are used over the lens, exposure compensation should be made by applying the filter factors normally used for these in black-and-white work. (See *Filter Guide,* by Norman Rothschild and Cora Wright.)

ADDING LETTERING TO SLIDES

The methods used for this will vary depending on the nature of the original, and on whether dark or light lettering is used.

Dark lettering is generally added to scenes having medium to light tones, since the characters would merge with dark tones. The simplest way to do this is to photograph light lettering on a black background, using contrasty black-and-white film and contrasty development. The result, which will have dark letters on a light background, can then be bound with the scene for projection.

Light letters are superimposed by double exposure in duplication. First photograph light letters on a dark background using reversal color or black-and-white film. Next the color transparency is placed in a duplicating setup and exposed. The film is not transported at this point, but the shutter is recocked. The lettering is then placed in the duplicator and a second exposure given for this. The color of the lettering in this operation may be controlled by the use of filters. Thus, by using a red filter for the lettering exposure, red letters will result.

Where black-and-white film is used, as in the first method, the image may be changed to red, green, blue, yellow, sepia, and other colors if desired by use of color toners such as those made by Edwal Scientific Products Corp., Chicago, Ill. 60628, and the FR Corp., Bronx, N. Y. The FR product is called Develochrome.

12

Filmstrip Making

A filmstrip is a single length of movie film on which are exposed or printed a series of related and connected images. There are a very few filmstrip machines that can show the standard "double-frame" 23 × 34mm slide area. However, the majority of machines show only filmstrips with a "single-frame" 17.5 × 23mm area, with the filmstrip running through the projector vertically.

Filmstrips have many advantages over lectures composed of individual slides. Where large numbers of copies are needed these are more easily prepared, in labs equipped for this purpose, than sets of individual slides. The lack of need for handling individual slides reduces costs. Since each picture doesn't have to be mounted, the labor and material costs for this are avoided. Another important factor is the saving in weight and storage space. The lower weight makes it possible to carry a greater number of lectures from one place to another.

Perhaps the most important advantage is that filmstrips can be shown by relatively inexperienced personnel with no danger of getting slides out of sequence, spilling the contents of a tray, damaging the cardboards, or breaking glass mounts. In addition to this, filmstrip projectors have relatively simple jam-

proof mechanisms. There is no chance of a show being interrupted by a damaged or unsuitable mount.

PLANNING A FILMSTRIP

Since the images in a filmstrip are to appear in some logical sequence, it is advisable to start out by listing the contents of each frame, and make rough outlines for the titles that are to appear between pictures. It's also a good idea to prepare a script. Next prepare a series of cards with rough sketches of each frame. A convenient size is a 4" × 6" index card. These should be mounted on a bulletin board in a sequence similar to that in the finished filmstrip. Where the original material is in color negative or slide form, a series of small color prints made to scale should be used in planning.

PREPARING ORIGINALS

Where the filmstrip is to be in color, preparation depends on whether or not location shots are to be included. Where the latter is the case, it may be best to render all final originals in slide form. You can then copy these onto the filmstrip, using a camera. Extreme care must be exercised in exposing originals. Whenever possible bracket exposures so slides of uniform density from each scene can be assembled for final duping. (See Chapter 9, "Requirements of Originals.") Where no location scenes are to be included, originals can be copied directly and can consist of flat artwork, or the titling letter sets used for movie work can be employed. (See Chapter 11, "Titling.") The final copying of original material is best done with a special single-frame camera such as those discussed later in this chapter. Where slides are to be copied with a standard double-frame camera, some provision must be made to expose half the film first and then the other half. With a setup in which the camera in use is making a three-quarter magnification copy, arrange to

be able to shift the 2″ × 2″ mount laterally a distance of 15/16 in. The Honeywell Repronar, with its special filmstrip attachments, will be found an excellent tool for this kind of work.

When copying flat artwork with a double-frame camera, a heavy cardboard mask with two openings should be made. This allows for exposing two originals at one time on a double frame. Once the mask is seen to be located properly on the groundglass, it is then fastened down and all artwork kept within mask limits. For single-frame cameras, a mask with only one opening is required.

A WORD ABOUT ARTWORK

It should always be borne in mind that artwork used in a filmstrip has only one end in view, to carry the message to the onlooker clearly. While this doesn't call for dull and uninspired captions and design, it does call for restraint from getting too "arty" and gimmicky—to the point where the onlooker is more interested in the cuteness of the images than their content.

From a purely visual point of view, it is imperative where lettering is used not to try to crowd too much fine print onto one frame. In addition to the possibility of illegibility, titles that are too long may become boring. If a lot of information must be imparted about a particular subject, it is better to break this down into several titles and pictures.

Whenever pictures are used, those having bold outlines rather than a lot of fine detail are easier to grasp quickly. Where much fine detail must be included, it's best to show first an overall view of the subject, then closeups of important areas.

Some ideas on the making and preparation of copy which can be adapted to filmstrip work will be found in Chapter 11, "Titling."

CAMERAS FOR FILMSTRIP MAKING

Ideally, where filmstrip making is to be done fairly frequently, a single-frame camera should be provided. These in-

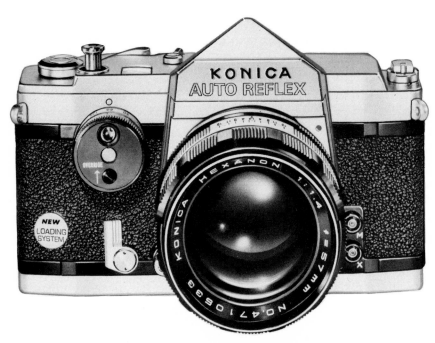

The original Konica Auto Reflex (above) makes half or full frames, and there is a special-order half-frame Alpa SLR. Olympus Pen F (below) simplifies production of filmstrips via its through-the-lens viewing system.

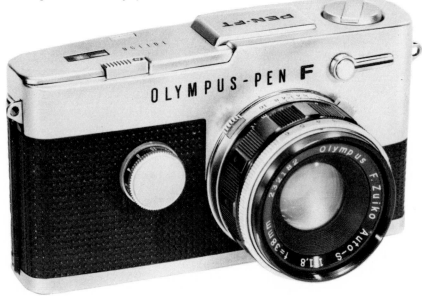

clude the Olympus Pen F, Robot 18, and special single-frame models of the Alpa Reflex.

Single-frame cameras yield 40 and 72 exposures on 20- and 36-exposure cartridges of film, respectively. If you wish to make longer filmstrips, or if you wish to do quantity production, cameras with greater film capacity must be used. The Robot 18 can be equipped with 30- and 200-foot magazines. Double-frame models of the Robot also take 30- and 200-foot magazines, while the double-frame Praktina takes a 250-foot magazine. Some commercial organizations use converted standard single-frame motion picture cameras for filmstrip work. These have the advantage of 100-foot or more film capacity and built-in motor drive. Details about such conversions may be obtained from Photo Application Co., Mineola, N.Y., Burke & James, Chicago, Ill. 60604, and Hernfield Engineering Corp., Culver City, Calif.

THE LEITZ REPROVIT

The Leitz Reprovit, a favorite tool of filmstrip makers, is designed for extensive work with a Leica camera.

Basically, the Reprovit uses a sliding focusing attachment to obtain sharp focus and determine the field of view. A novel feature of the Reprovit is a 100-watt focusing lamphouse, which mounts over the groundglass. This projects an outline of the groundglass area and the focusing pattern in the center of the groundglass onto the baseboard. After the projected image is brought into sharp focus, all flat originals placed into the projected area will be in sharp focus. The projected outline also determines the field of view to be seen by the lens. After focusing and composing, the Leica camera body is slid into place and the exposure made.

A great number of accessories are available for the Reprovit which make the task of the filmstrip maker easier. These include a set of four copying lights, light boxes for copying transparent or translucent subjects, and copy holders for books and manuscripts.

Durst Enlarger fitted with 35mm Mirep Cassette and copying lights is useful for filmstrip making, titling, and production of slide dupes in quantity.

Several models of the Reprovit are available, differing in details of the focusing arrangement and upright post. For field use or economy the focusing lamphouse can be removed and a regular Leitz focusing magnifier used over the groundglass.

The Reprovit is also eminently suited for making dupes in quantity (Chapter 8) and for titling (Chapter 11).

Full details on the various Reprovit models and equipment may be obtained from E. Leitz, Inc., Rockleigh, N. J.

CHOICE OF SENSITIVE MATERIALS

The characteristics of film material outlined in Chapter 10 should be studied before you choose a film for filmstrip making.

In general, one of the reversal transparency materials will be used for the majority of small-scale filmstrip work. Where larger quantities of slides are required, it may prove advantageous, especially when working from flat copy, to employ a negative color film such as Kodacolor and have the final filmstrip printed on Ektacolor Slide Film.

A problem that is ever-present whenever relatively large numbers of color pictures must be produced is film cost. The answer to this is to purchase film in bulk rolls and reload empty cartridges. This is covered in Chapter 8.

While this book is primarily devoted to the making of color pictures, it should be noted that in filmstrip making black-and-white plays a considerable role. Space does not permit a complete rundown on the great myriad of films, developers, and other materials available for black-and-white work.

In general a slow or medium speed fine-grain film coupled with a soft-working developer will be found easiest to use for continuous tone originals. Avoid trick developers. Adhere to the film maker's formula, or a *well-tested* pet developer whose characteristics are well known to you. For line copy, use films such as Kodak High Contrast Copy, Ansco Hyscan, DuPont 802, Agfa Agepan, and Adox Dokupan, plus a high contrast developer recommended by the manufacturer. Kodak Fine Grain Positive film may also be used for copying both line and continuous tone material. It has the advantages of low cost and the ability to be loaded into cartridges and developing tanks by a relatively bright red 1A safelight. With care, a paper safelight, such as an OC or 55-X, may also be used. Progress of development can be watched, and *with experience* stopped at the appropriate time. Disadvantages of fine grain positive is very low sensitivity, necessitating long exposures or powerful subject illumination, lower resolution than high contrast copying films when doing line work, and lack of color sensitivity. Kodak Fine Grain and other similar positive films are blue sensitive only, making them suitable primarily for copying black-and-white subjects, or oth-

ers in which the rendition of reds, greens, oranges, and yellows as dark is not objectionable.

After the negatives have been shot and processed, the final filmstrip is made by printing on Kodak Fine Grain Positive, Du-Pont Fine Grain Release Positive, or Gevaert Positive Fine Grain. The latter two films are sold in 1000-foot and longer rolls only, whereas the Kodak material is also available through retail stores in 100-foot rolls.

Printing from filmstrip negatives is generally done by contact. Apparatus specially suited to this include the Heitz Super-contact and Colorcontact printers; the Leitz Eldia printer (see Chapter 3, "Contact Duplicating"); and the filmstrip duplicating attachment for the Heiland Repronar (see Chapter 8, "Duping Slides in Quantity"). Where mass production of filmstrips is contemplated, 35mm cine-printers are often used.

Where only a single filmstrip is needed, you may find it convenient to shoot it on Kodak *Direct* Positive Pan or Panatomic-X film. These can be processed to a positive directly using the Kodak Direct Positive Film Developing Outfit. Details on this procedure may be obtained by writing the Sales Service Division, Eastman Kodak Co., Rochester, N.Y. NOTE: Do not confuse Kodak *Direct* Positive Pan, which is a reversal film, with Kodak **Fine Grain Positive**.

13
Creative Slide Duplicating

The choice of the word "duplicating" for making copies of color slides has an unfortunate connotation. It implies that what we're trying to do is to make an exact copy of the original. I do not deny that this is sometimes necessary. It is by no means a simple procedure. It requires much testing, filtration, and in some cases masking of the original. What is more often done, when slide duping equipment is brought into play, is to improve the image quality of the original, or to drastically change the appearance of things in order to have an entirely new picture. The number of techniques for doing these things is endless. How many of them you will want to master and how many more you'll discover or concoct depends on your needs and experience with the medium of photography. Let's present a few here.

CORRECTING FAULTY EXPOSURE

A slide that has plenty of detail, but is somewhat underexposed and too dark to project or view properly may be corrected in duping, by giving the dupe adequate exposure. An overexposed slide is not easy to correct. Once highlight detail is missing, it cannot be restored by corrective exposure in duplicating.

An attempt to do this will generally result in a flat-looking dupe with degraded highlight areas. Very slightly overexposed slides may however be somewhat corrected by underexposing during the dupe exposure.

CORRECTING FAULTY COLOR

Slides that have an undesirable color balance or a color cast can often be corrected by proper use of CC or CP filters in duping. The filter should be of the opposite color to the one that is to be removed. The following chart will prove helpful:

If the overall balance is too	Use filter(s)
Yellow	Magenta + cyan, or blue
Magenta	Yellow + cyan, or green
Cyan	Yellow + magenta, or red
Blue	Yellow
Green	Magenta
Red	Cyan

To arrive at the proper density of CC or CP filter to use, view the transparency with various strengths of filter until it looks okay. Then use that color, but half the strength of the depth used for viewing, on the exposing system. Examination of the final result may indicate some further filter change, which can then be done.

It is also possible to warm up or cool a slide by use of yellowish 81, or bluish 82, light-balancing filter, respectively.

Where there are no strong highlights, or white areas showing it may also be possible to make corrected dupes from slides exposed to the wrong kind of light. For example, slides that are made on tungsten-type film by daylight and are too blue may sometimes be given new life by copying them through an 85, 85B, or 85C filter. Conversely, slides that are too warm, because daylight-type film was exposed by clear flash, photofloods, or

3200 K lamps, can sometimes be copied through an 80A, 80B, or 80C filter for good results.

USE OF BLACK-AND-WHITE FILTERS

Deep-colored filters such as red, green, blue, yellow, magenta, and cyan may be used in duping for wild or off-beat results. The best effects are generally obtained by combining images from different slides, making double or multiple exposures, using a different-colored filter for each. When doing this, light images on a dark background work best. It should also be remembered that mixing colors additively, as when making multiple exposures does not give the same result as when mixing dyes or pigments on paper or canvas. The following chart will be helpful:

Mixing Light	
Red + green exposure =	Yellow
Red + blue exposure =	Magenta
Green + blue exposure =	Cyan

USE OF CC AND LIGHT-BALANCING FILTERS

Previously mentioned for corrective use, these may also be used interpretively. For example, use of a blue CC filter may help accent the coldness of a fog scene. A yellow CC or light-balancing filter may help add a feeling of sunniness to a cold slide. A red CC filter may be used to simulate a late afternoon feeling. These are only a few prescriptions. As you experiment, viewing your slides through various filters, you'll soon come up with your own prescriptions.

MULTIPLE EXPOSURES AND SANDWICHES (MONTAGES)

Combining two images to obtain a third and with a new, heightened meaning is an old game in black-and-white photog-

raphy. In color, it can take on still further meaning, since the interplay of the colors in the various slides used this way gives an additional dimension to things.

CROPPING

If you've made something in the camera which is not composed just the way you'd ultimately like it to appear, just enlarge the portions you want while copying. Depending on sharpness of the original, it is sometimes possible to eliminate as much as two-thirds of the original subject matter in a slide to concentrate on what is really important.

INCREASING CONTRAST (POSTERIZING)

Most camera shooting films will give a moderate contrast increase when used for slide copying. This will be found helpful when the original is somewhat flat and dull in color. A really zany effect can be obtained by recopying the dupe. This increases the contrast still further. If at this point you are happy with the bizarre, posterish color you've gotten—quit. But if you wish to experiment further, dupe the dupe of a dupe once more. By this time, most middle tones will have disappeared giving you flat washes of color. When going from one stage to the next, there may be some color shift in an unwanted direction. This can be corrected at each stage by filters.

MISCELLANEOUS TECHNIQUES

For negative images, dupe with Ektachrome-X or Fujichrome R 100, using EI 200 and 300 as a basis for experimentation. Then have the film processed by a custom lab in C-22, Kodacolor solutions. Not only will tonal values, but also colors be reversed. Thus, a red rose on green leaves, for example, will come out a green rose on magenta leaves. Other color combina-

tions will occur to you as you sally forth making new negative image color slides.

Other ideas include: copying through a multiple image prism; using a magnifying glass as the lens for soft focus effects; placing textured glass or a texture screen in contact with the slide; copying by laying a cylindrical lens atop the slide for anamorphic effects; and moving the slide during duping. Still further, use of a kaleidoscope can also give startlingly different and new color results.

BLACK-AND-WHITE

It should not be forgotten that color slide duplicating equipment can also be used to convert color slides into black-and-white negatives for subsequent printing on black-and-white paper. At this stage you can aim for normal contrast, or for ultra high contrast by copying on a film such as Kodak High Contrast Copy 35mm film, or process or litho sheet films.

Index